THE GOOD –
THE BAD

THE GREATEST HEROES
AND VILLAINS IN
THE HISTORY OF FILM

TECTUM
PUBLISHERS

Tectum Publishers of Style ©2011

Tectum Publishers NV
Godefriduskaai 22
2000 Antwerp Belgium
+32 3 226 66 73
www.tectum.be

ISBN: 978-90-79761-66-1
WD: 2011/9021/16
 (129)

Author: Fien Meynendonckx
Graphic Design: Splend-ID (Jennifer Schleber)

Printed in Spain

THE GOOD –
THE BAD

**THE GREATEST HEROES
AND VILLAINS IN
THE HISTORY OF FILM**

TECTUM
PUBLISHERS

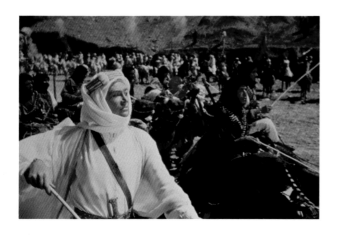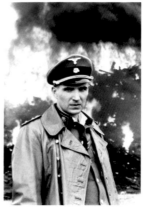

INTRODUCTION

From super-evil bad guys like Lex Luthor,
to the heroic actions of Indiana Jones. In the
movies, we find them all: the gangsters and
the coppers, the psychos and the superheroes.
In this book we gathered 125 of the greatest
heroes and villains in the history of film,
complete with pictures, a short introduction
and memorable moments and quotes. On top
of that and to avoid confusion: every character
gets a score on 10, to establish his "good- or
evilness".
Meet Rocky, Don Corleone, Jason Bourne,
Ellen Ripley and many, many more. With
this book, we try to delight movie fans all
over the world, by letting them run in to the
most famous and most forgotten characters.
Hopefully, you are encouraged to watch these
movies (again and again) ...

THE GOOD –
THE BAD

THE GREATEST HEROES AND VILLAINS
IN THE HISTORY OF FILM

TABLE OF CONTENTS

LEGEND

 Spoiler Alert: An important part of the plot is revealed in the text.

Movies in which the character appears

Scale
1 5 10

Who is this character?

1 is very good, 10 is truly bad.

 Memorable moment

 Oscar Winner 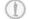 Oscar Nominee

GANGSTERS AND COPPERS

Of all the bad guys, gangsters appeal to the imagination most. They have therefore been portrayed on numerous occasions. Don Corleone from *The Godfather*, Al Capone, Bonnie & Clyde: we all know them and nearly consider them to be our friends. It is not unusual that we sympathise with the bad guys. This is perhaps due to the world they live in: one of freedom and an abundance of wealth. Although they are often thoroughly bad and their evil even takes on mythical proportions... On the other hand, there is the arm of the law, the 'coppers', who equally have their flaws and can be touchy at times. It is remarkable that the average film policeman takes no notice of the law, enjoys leaving a trail of destruction and uses more expletives than a drunk - if he is not one himself. But do not be mistaken, there are some true heroes! The following chapter clearly highlights the fine line between good and bad, illustrating the most iconic gangsters and famous policemen.

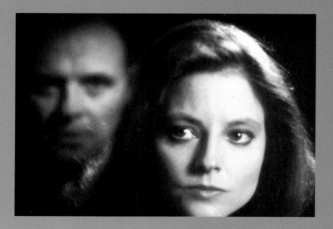

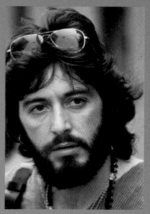

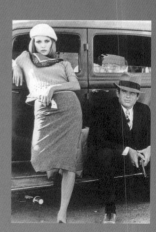

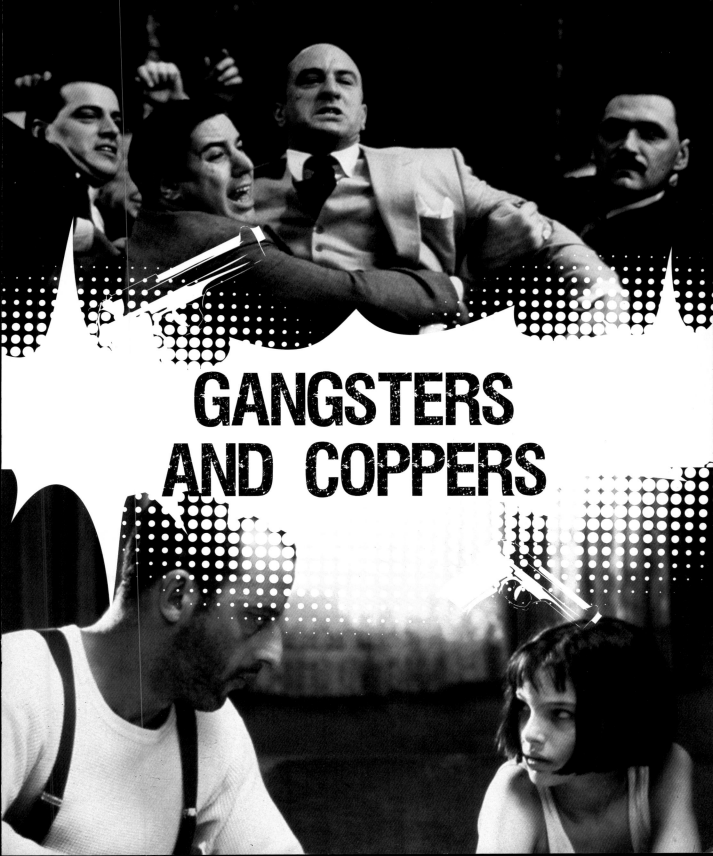

GANGSTERS
AND COPPERS

AL CAPONE
ROBERT DE NIRO

the Untouchables (1987) –
Brian de Palma

Al Capone was an American gangster
who made his name during the Prohibition
Era in Chicago as the leader of a criminal
organisation (known as the *Chicago Outfit*).
His business card described him as a trader
in second-hand furniture, however, his
specialism was mainly the smuggling of
alcohol with the whole city, including its
prominent figures, as his customers. He has
been a favourite subject for many film and
television producers but his most famous
rendition was portrayed by Robert de Niro in
The Untouchables by Brian de Palma. It is
said that the actor even wore suits made by
Capone's tailor in order to have a better
understanding of his character. Stanislavski
all over. But it works. De Niro made Capone
an even more notorious figure than he
already was.

A moment that perfectly illustrates Al
Capone's character in *The Untouchables* is
when he talks about baseball. He addresses
his cronies whilst they are enjoying a cigar.
Capone talks about the importance of the
'team' when trying to reach personal goals
and vice versa. Whilst everyone is nodding
approvingly, he suddenly beats one of his
men to death with a baseball bat - possibly
due to his lack of team spirit. Al Capone is
captivating but cruel. A brutal beast. An
ordinary scoundrel wearing a fancy suit who
thinks he stands above the law.

1 5 10

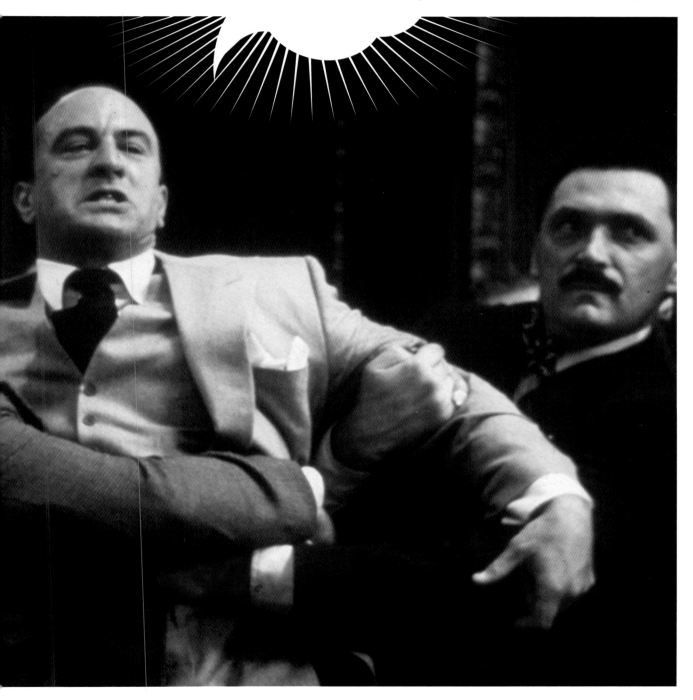

BONNIE & CLYDE
FAYE DUNAWAY ⓘ & WARREN BEATTY ⓘ

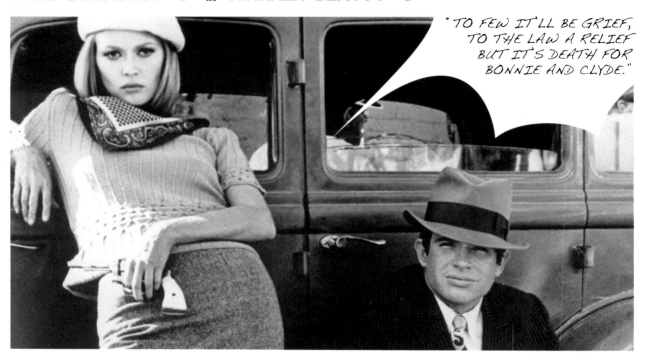

"TO FEW IT'LL BE GRIEF, TO THE LAW A RELIEF BUT IT'S DEATH FOR BONNIE AND CLYDE."

 Bonnie and Clyde (1967) – Arthur Penn

This famous US couple, notorious for robbing banks during the Depression, became immortal thanks to the landmark film by Arthur Penn. The style, inspired by Truffaut and Godard amongst others, was the start of the *New Hollywood*. At first, the film received bad reviews because of its direct approach to sex and violence until the famous critic Pauline Kael backed the title. Thank goodness. Bonnie (a giggling and endearingly sensual Faye Dunaway) and Clyde (a confident but shy Warren Beatty with the right looks) first meet each other when he tries to steel her mother's car. She decides to join him in his activities and, together with his older brother Buck (Gene Hackman) and his wife Blanche (Estelle Parsons), they form the *Barrow Gang*. Their robberies become increasingly more violent, and they, more and more famous. Bonnie and the impotent Clyde do not have a sexual relationship until the end, when Bonnie's poem and photographs of them both are published.

The controversy of this film is mainly due to the ending. Although hardly any blood is spilt on screen, it is a graphic and expressive dying scene which is known as one of the most atrocious in film history. Bonnie and Clyde are betrayed by the father of C.W. Moss, their driver and mechanic. They stop to help him with a flat tyre, unaware that police is waiting for them in the bushes with machine guns. They briefly exchange looks, realise they have been ambushed and from then on, they are killed in slow motion. It is like a modern dance; bullets that perforate their bodies. The editing makes it look like they are being shot over and over again. It is shocking and out of this world beautiful.

1 5 10

CLARICE STARLING
JODIE FOSTER ⓘ

the Silence of the Lambs (1991)
– Jonathan Demme
Hannibal (2001) – Ridley Scott

Additional actress: Julianne Moore

We know the young and naive Clarice Starling through the amazing performance of Jodie Foster in *the Silence of the Lambs* (based on the novel by Thomas Harris). In order to catch serial killer Buffalo Bill, she has to attain the cooperation of cannibal psychiatrist Hannibal Lecter who is kept under strict security in prison. Their relationship grows to one of mutual respect which is - beyond romance - erotically tinted. The sequel *Hannibal*, applauded by the general public but reviled by critics, further develops this relationship ten years on. Clarice is then played by the beautiful Julianne Moore, who gives a convincing rendition but whose character misses the uninhibited charm from the past. Clarice has become a tougher and more cynical person due to the experience she has since gained. The chemistry between the main characters is far less present than in the dawdling but yet highly praised *the Silence of the Lambs*.

Although the opening scene of *the Silence of the Lambs* doesn't show anything more than Clarice training in misty woods, it sets the atmosphere for the rest of the film. The music is - deceivingly - threatening, and Clarice determined. In the finale, where she finds herself in a dark cellar, alone and angst-ridden but with the same determination confronting Buffalo Bill, we see her through night vision goggles, which shows her most vulnerable. Much admired are also the scenes in which Jodie Foster and Anthony Hopkins have conversations separated by a glass wall. In particular, the scene where Clarice talks about her traumatic experience as a child – something about crying lambs, you know.

1 5 10

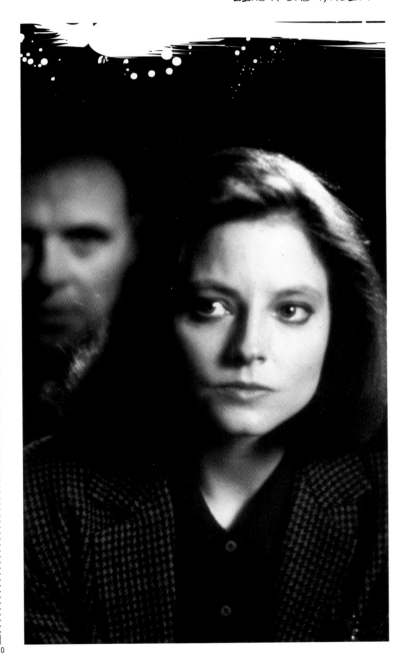

"HE'S ALWAYS WITH ME. LIKE A BAD HABIT."

CODY JARRETT
JAMES CAGNEY

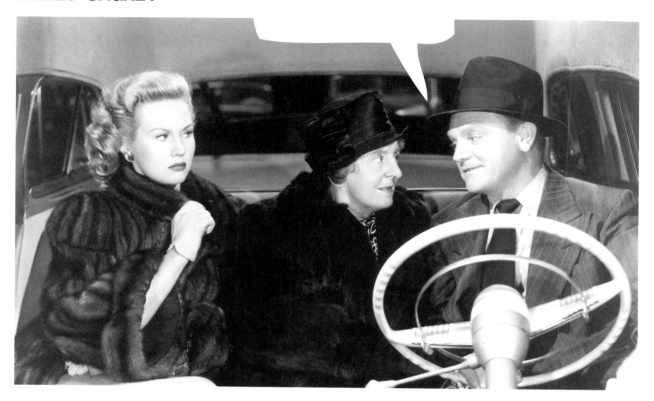

"MADE IT, MA! TOP OF THE WORLD!"

 White Heat (1949) – Raoul Walsh

This classic gangster film approaches violence with a business-like attitude, as it is the psychology of the characters – who see murder as part of their business plan – that is key. Cody is a ruthless leader of a criminal gang but is extremely attached to his mother. He really doesn't have anyone else apart from his Ma as all his best friends have a secret agenda (they are either sleeping with his wife or are undercover agents). Cody suffers from headaches – which used to be imaginary and a cry for attention – but are now painfully real. When he has a migraine, all his frustration and vulnerability surface. You nearly feel for him. Cagney, with his harsh voice, portrays him as a tired and bloated, though human and credible gangster. For the audience, this film is a difficult task: back the policeman or show support for Cody.

It is perhaps incredible that a gangster of Cody Jarret's calibre breaks down on his mother's lap, but it is those emotional moments that make *White Heat* unique. The psychotic attack when he is told that his mother has died, or the endearing explanation about the Trojan Horse, as if she made up the story herself: they all make us take this rather heartless gangster to our hearts. The end of the film is legendary. Cody is surrounded by police but doesn't surrender. When he is standing on top of a gas tank, he calls out to his mother one last time before the whole thing turns into one gigantic explosion.

1 5 10

FRANK SERPICO
AL PACINO ①

⚠️

🎬 *Serpico* (1973) – Sidney Lumet

🏷️ Frank Serpico is a character based on a New York policeman of the same name. He starts his childhood dream job as an idealist. It is not long before he is considered to be an outsider as his long hair and beard make him look like a hippie. After a while, it emerges that all officers in New York take bribes, which even their superiors approve of. Serpico refuses to join in with this scam and wants to raise the alarm. He soon finds himself the subject of snide remarks from the other officers who would rather not see their lucrative activities come to an end. Serpico becomes embittered by his lonesome battle.

🎬 This film is remarkable as it is not a conventional police film: the main character is portrayed in great detail and as a strong individual although Pacino gives him a delicate touch. Memorable is the long dreaded scene: when will Serpico be lead into a trap by his colleagues? This happens during a raid on a drug dealer. The other police officers purposefully wait a little too long to come to the rescue and he is shot in the face. A paradox perhaps, but it nearly feels like a relief: now he is confronted with it, he will no longer have to fear the consequences of his integrity.

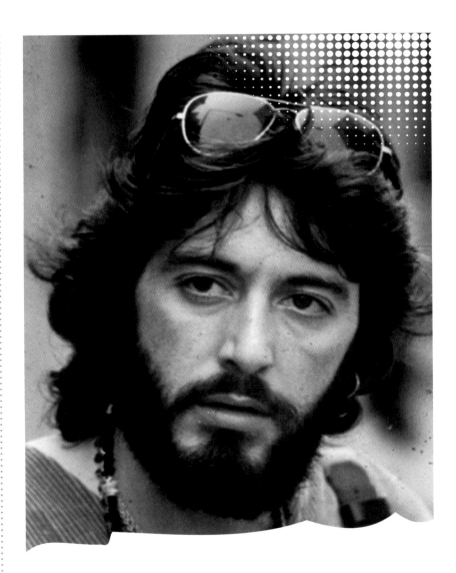

"THE REALITY IS THAT WE DO NOT WASH OUR OWN LAUNDRY – IT JUST GETS DIRTIER."

1 5 10

HANS GRUBER
ALAN RICKMAN

 Die Hard (1988) – John McTiernan

Alan Rickman once said in an interview that Hans Gruber is not a bad guy but simply a man who has made the choice to achieve the goal he set. Although the actor knows him best, it is difficult to agree: Gruber enters a block of flats with a gang, takes hostages and pretends he is a terrorist with shocking intentions, however, he is simply an ordinary (though talented) and ruthless thief. He stands out with his special beard, his German accent and Rickmanian tone of voice – think: '*Ho Ho Ho*'. In *Die Hard With a Vengeance* (1995), his brother (Jeremy Irons as Simon Gruber) appears as the rogue. One family trait comes to light: he pretends to be after John McClane (Bruce Willis) as revenge for his brother's death but the underlying reason is simply to steal an enormous amount of money (this time in the form of gold).

Hans Gruber is a true villain who you love to hate. It is always nice when he appears. To narrow it down to one moment: he bumps into John McClane when he wants to inspect the explosives and pretends to be a terrified hostage. His accent makes the policeman doubtful: surely he should not shoot down an innocent man? McClane gives him an unloaded gun and in the end he manages to escape after all. His death is also much discussed: he falls in slow motion from a window, with a look full of disbelief, fear and anger. Priceless. And if you like to have a laugh at gangsters: have a look on the internet for the animation film in which Professor Snape from Harry Potter (another famous performance by Rickman) thinks he is Hans Gruber. Funny.

1 5 10

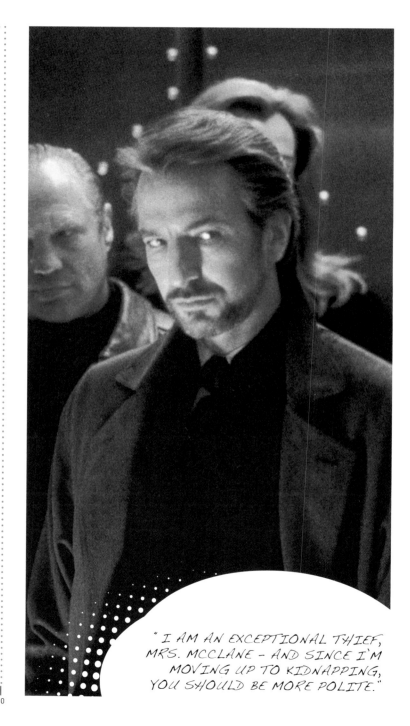

" I AM AN EXCEPTIONAL THIEF, MRS. MCCLANE – AND SINCE I'M MOVING UP TO KIDNAPPING, YOU SHOULD BE MORE POLITE."

HARRY CALLAHAN
CLINT EASTWOOD

" GO AHEAD, MAKE MY DAY."

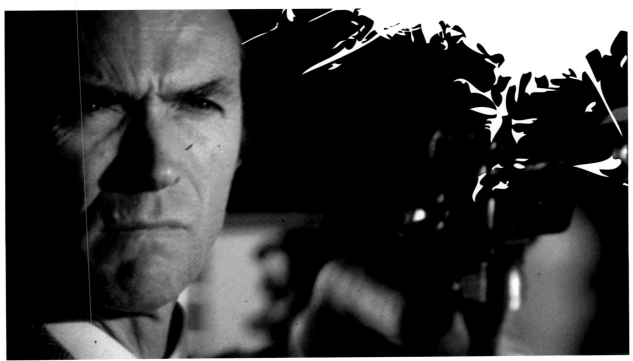

Dirty Harry (1971) – Don Siegel, *Magnum Force* (1973) – Ted Post, *The Enforcer* (1976) – James Fargo, *Sudden Impact* (1983) – Clint Eastwood, *The Dead Pool* (1988) – Buddy Van Horn

Harry Callahan is a police inspector from Los Angeles. He resolves mysteries, bank robberies and suicide attempts in a flash, even during his coffee break. But naturally, there is a reason why he is nicknamed Dirty Harry. He is a voyeur, always sorting out the dirty jobs and mainly: he is not bothered about the law in the slightest. During the hunt for Scorpio, who has captivated the city with his murderous plans, he violates the *Bill of Rights* four times, resulting in the release of the psychopath. Eventually Harry shoots him and throws away his police badge. Opinions about this character vary greatly, though it is clear, since the first film, that he is portrayed as a parody of himself: a type of primitive warrior who is subjected to the rules of society.

The most memorable Dirty Harry moment appears twice in the first film. A nearly bored Inspector Callahan has his gun pointed at a gangster when he says the famous words *"You've got to ask yourself just one question: 'Do I feel lucky?' Well, do you, punk?'*. He refers to the number of bullets in his gun. If the gangster has luck on his side, the barrel is empty. The first time, this happens to be the case but the attacker doesn't want to run the risk. The second time, he is less lucky and Scorpio dies. This approach characterises Dirty Harry and it instantly becomes a classic film moment.

1 5 10

JACK TRAVEN
KEANU REEVES

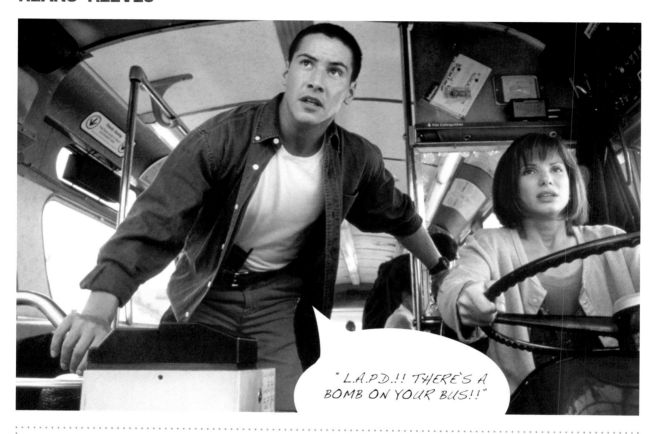

" L.A.P.D.!! THERE'S A BOMB ON YOUR BUS!!"

Speed (1994) – Jan de Bont

The story behind *Speed* is straightforward: there is a bomb on a bus. If the bus goes less than 50 mph, it explodes. The hero of the film is equally uncomplicated: Jack Traven is an efficient, reliable policeman whose speciality includes taming derailed lifts, runaway busses and other fun. He literally is an action hero: the action in this film is more important than the depth of the character. It is therefore surprising that Keanu Reeves manages to give his character a human aspect, despite his often glazy looks and rather serious personality. He is upfront, frowns meaningfully from time to time and follows the fast pace of the film perfectly. The short conversations with Sandra Bullock are there to suspend all the action, and they work perfectly.

The film consists of an introduction, a constant chase and a short epilogue. The action scene takes up approximately three quarters of the film. Not surprising that this seems to be the only thing we can remember. We also don't seem to struggle over certain implausibilities: Why does Traven simply not stop the bus before the speed exceeds 50 mph and the bomb gets activated? Because one of the most entertaining action films of the '90s would not have made it otherwise, obviously. To mention one scene: In an attempt to defuse the bomb, Jack disappears underneath the bus on a glorified skateboard. When the cart dangerously sways and ends up under the wheels, he finds himself hanging from the fuel tank. Until they pull him back into the bus via a hatch. Good work.

1 5 10

JOHN MCCLANE
BRUCE WILLIS

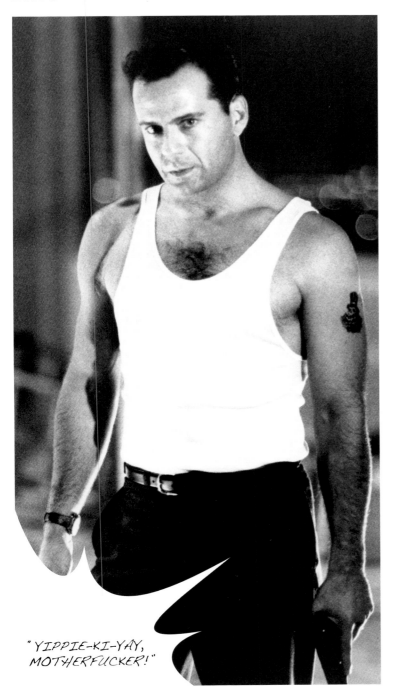

"YIPPIE-KI-YAY, MOTHERFUCKER!"

Die Hard (1988) – John McTiernan, *Die Hard 2* (1990) – Renny Harlin, *Die Hard: With a Vengeance* (1995) – John McTiernan, *Live Free or Die Hard* (2007) – Len Wiseman

John McClane is a true antihero: he is rude and literally a saviour against his will. He simply cannot resist destroying everything in his path and to eliminate his enemies in the bloodiest way possible. Or as his wife puts it: 'Only John can drive somebody that crazy.' He continuously mutters that he wants to be somewhere else but it is this that shows his human side which we find ultra-charming. And yet, he keeps on going: preventing a kidnapping, foiling an attack and killing the most important terrorists. Four films long. Against his will. Hats off.

During the very first scene on a plane, an anxious McClane is advised to 'make fists with his toes', which should be calming. Once he has arrived at his wife's office, he tries this out, exactly at the moment when the gang appears. Result: he walks around barefooted during the rest of the film, which makes you sit on the edge of your seat, especially when Hans Gruber shoots all the windows and John has to run over the pieces of broken glass in order to escape. The meeting with his 'partner' Zeus (Samuel L. Jackson) in *Die Hard with a Vengeance* is also legendary: McClane has to stand in the centre of the black neighbourhood Harlem with a racist message on a board. Eventually, Zeus rescues him from this tricky situation.

1 5 10

KEYSER SOZE
KEVIN SPACEY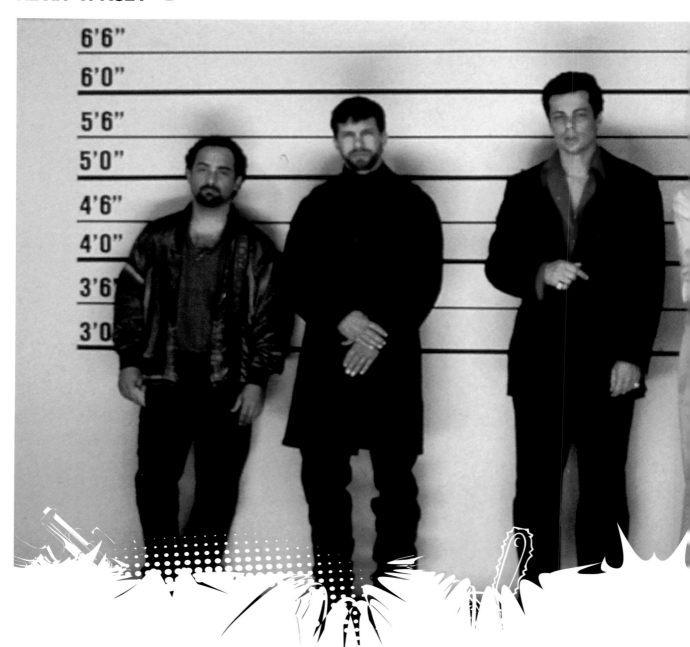

"THE GREATEST TRICK THE DEVIL EVER PULLED
WAS CONVINCING THE WORLD HE DIDN'T EXIST."

"I'M GOING TO MAKE HIM AN OFFER HE CAN'T REFUSE."

The Godfather (1972) en *The Godfather part 2* (1974) – Francis Ford Coppola

The Godfather has become the standard for the mafia film, thanks to Brando and De Niro. Brando's frequently imitated mumbling has become iconic, although the producers were afraid he would need subtitles (he first used Kleenex, then a mouthpiece). Vito Corleone is a Sicilian immigrant who, in 1917 in New York, is forced to become successful by breaking the law. The second film shows his rise in the neighbourhood. Although he is the dominant figure in the first film, he has no leading part. He is a man of honour and true to his family and friends, he likes gardening and his grandchild, and sometimes we even forget that he made his name through murder, prostitution and bribery – something we could not possibly fail to remember with his unprepossessing son Michael Corleone. Don Vito deserves our respect.

The Godfather is cited and imitated endlessly. Without doubt, it is Marlon Brando's incarnation that appeals to the imagination: the nondescript authoritarian who lays down the law. It is Brando who decided that he wanted the character to look like a bulldog, hence the puffy cheeks. This had an effect on his speech and acting, and we can all agree that this gives for a genius rendition of this legendary character. The scene everyone remembers is when he dies at the end of the first film from a heart attack whilst playing in the tomato garden with his grandson. A peaceful death, perfect for a man who held his family very dear, although he was responsible for the cruel death of many others...

FUNNY FACES

The following heroes and villains prove that the good and the bad can also be incredibly funny. The funniest characters take themselves far too serious whilst they lack something in every aspect. They are clumsy, whether they try to be a hero or the biggest badass. This category features characters who, at first sight, do not want to be funny but who make us smile nevertheless. Or who move or amuse us, without pretension. From over the top, such as Jacques Clouseau and Austin Powers, to a more modest Danny Ocean and Marge Gunderson. They all leave us with a warm feeling. For some laughter and a cry, amusement and modest entertainment: there is something to suit all tastes, in every genre and role.

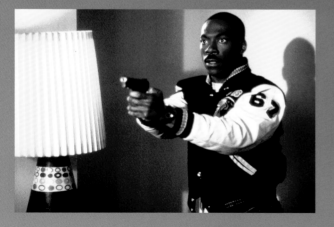

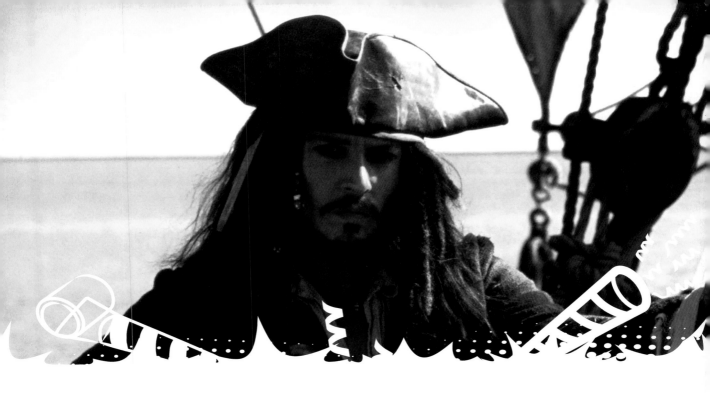

FUNNY FACES

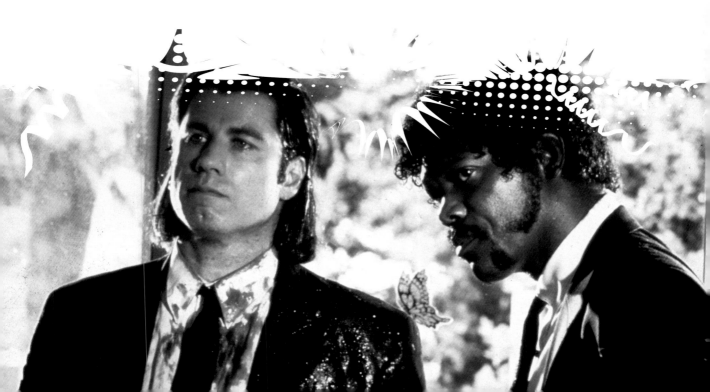

AGENT JAY & AGENT KAY
WILL SMITH & TOMMY LEE JONES

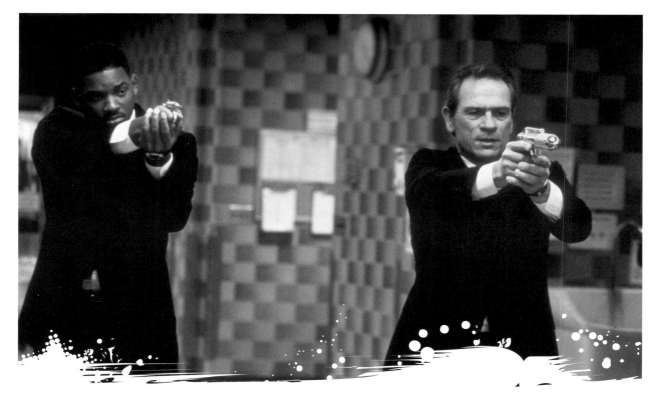

" YOU SEE THIS? HUH?! NYPD! MEANS I WILL" NOCK YOUR PUNK-ASS DOWN!""

📋 *Men in Black* (1997), *Men in Black II* (2002),
Men in Black III (2012) - Barry Sonnenfeld

🏷 The *Men in Black* films are based on a comic book series, published by Aircel Comics, about a government organisation that has to monitor, and keep secret, any alien activity on earth. The organisation employs police officers who are stripped of their name and identity, such as Agent K (Tommy Lee Jones). Agent J (Will Smith) is recruited after he became first at an exam, although it did show him to be the most independent spirit. Both agents have to work together which results in hilarious situations.

In the first film, J learns the ropes from K; in the second film, the roles are reversed when Tommy Lee Jones cannot remember his job at MIB. He works as a postmaster and in order to (what else?) save the world, J has to make sure that his memory returns. There are a number of surprisingly funny scenes in which the actors are clearly having as much fun as the audience: for example, Will Smith who sits the exam, without knowing its true purpose, and twists everything and everyone (including his fellow competitors) around his little finger. Awkwardly funny. Should also be mentioned: the Neuralizer or *that flashy thingy* with which they wipe memories; guaranteed entertainment.

1 5 10

AUSTIN POWERS
MIKE MYERS

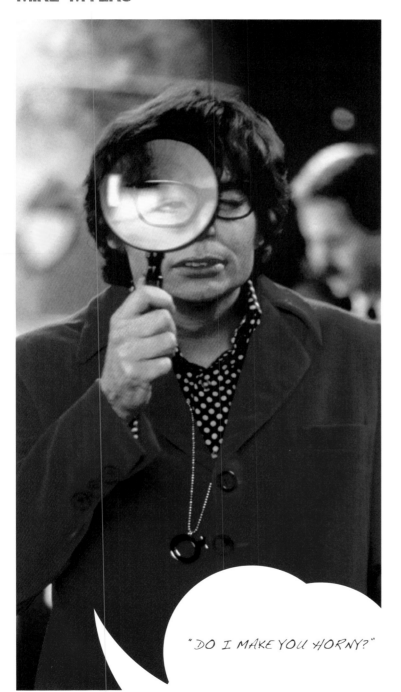

"DO I MAKE YOU HORNY?"

Austin Powers: International Man of Mystery (1997), *Austin Powers: The Spy who shagged me* (1999), *Austin Powers in Goldmember* (2002) - Jay Roach

Austin Powers is a British secret agent from the sixties who, in order to stop his enemy Dr. Evil (also played by Myers), is unfrozen in the nineties. He preaches a free love credo, is accompanied by ladies with names such as Alotta Fagina and has more chest hair than Sean Connery. Both Powers and Dr. Evil are a product of the time they parody: James Bond, the Beatles and the sixties in general. Everything is blown out of proportion into a shameless and shabby affair that is still enjoyable and yes, even funny. Austin's character is the strongest facet: he is naive but sincere and enthusiastic. And justifiable. His power comes from his sexual energy, his 'mojo'. At one point, Dr. Evil steals the physical representation of this, which leaves Powers impotent, and literally powerless.

The *Austin Powers* films are not carried by their storyline but by their humour. The choreography that is involved to hide Powers private parts when walking around naked through a hotel room is hilarious. In the second film, we see something similar, though this time around in the form of a (hardly subtle) shadow play. References to James Bond for example are also amusing. The scenes seem to be drawn out but because of the anachronism, not much had to be changed: Dr. Evil will never kill Powers when he has the chance, the unknown accomplices are easily beaten, the other characters are all serious and women are willing.

1 5 10

AXEL FOLEY
EDDIE MURPHY

"THIS IS THE CLEANEST AND NICEST POLICE CAR I'VE EVER BEEN IN IN MY LIFE. THIS THING'S NICER THAN MY APARTMENT."

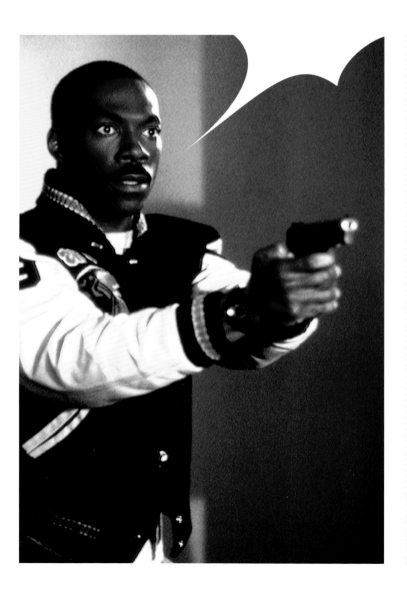

Beverly Hills Cop (1984) - Martin Brest, *Beverly Hills Cop II* (1987) - Tony Scott, *Beverly Hills Cop III* (1994) - John Landis

In the first film, Axel Foley is a policeman from Detroit who heads to LA to investigate the murder of his best friend. As are most (and the best) policemen in films, he is rather creative with the law. Classy and civilised Los Angeles is the ideal place to let a messy Foley loose: action and humour go hand in hand. This mix is further backed up by superb eighties synthesizer music and his personal theme tune.

Axel Foley's laugh is that of Eddie Murphy, and you cannot help but join in. Even something that is not funny becomes hilarious when Axel roars with laughter. Most often quoted is a running joke from the first film: the *'banana in the tailpipe'* moment. Axel is being followed by two policemen who are parked in front of his hotel. Whilst he distracts them by ordering room service to their car, he puts a banana in their exhaust so they are unable to chase him later on. Things get even more hilarious when Axel laughs at another (black) policeman because his pronunciation of *'banana in the tailpipe'* is not homey enough.

1 5 10

CAPTAIN JACK SPARROW
JOHNNY DEPP ①

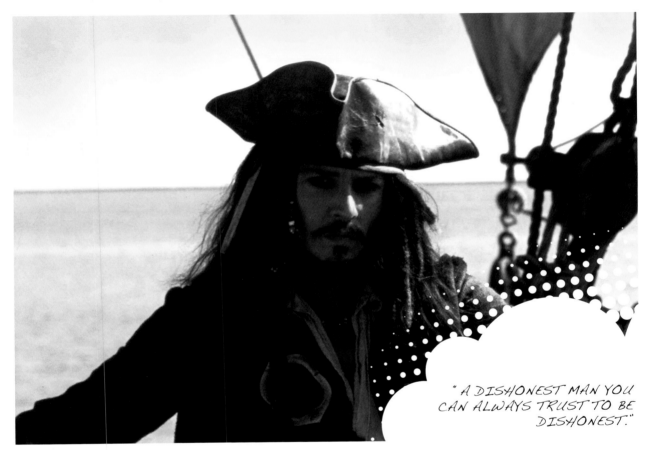

"A DISHONEST MAN YOU CAN ALWAYS TRUST TO BE DISHONEST."

Pirates of the Caribbean: The Curse of the Black Pearl (2003), *Dead Man's Chest* (2006), *At World's End* (2007) – Gore Verbinski, *On Stranger Tides* (2011) – Rob Marshall

Although Jack Sparrow was not part of the original theme park attraction that the *Pirates of the Caribbean* films were based on, he has now joined the club. His immense popularity is the result of the successful franchise - or was it the other way around? Since these films, Johnny Depp is no longer considered '*box office poison*', moreover: he is the star of the story. Pretty boy Orlando Bloom cannot compete with Capitan Jack Sparrow's charisma, the most unreliable of all pirates, although he wears his heart in the right place (or does he?).

The funniest moments are those when Jack Sparrow outsmarts the others and misleads them with an ingenious plan until no one (including the audience, and possibly himself) knows what he means. The most iconic moment is his introduction in the first film, at his arrival at Port Royal, a scene which immediately shows his duality: the music and first shot are heroic; he is aloft with the wind in his hair. Soon we see that his ship is a small sinking sailing boat. By the time he reaches the shore, the thing is fully under water.

1 5 10

CARL SHOWALTER & GAEAR GRIMSRUD
STEVE BUSCEMI & PETER STORMARE

Fargo (1996) – Joel Coen

Fargo is the story of the perfect crime that goes wrong. Although it was a disaster waiting to happen due to the mismatch and total incompetence of its executors. Showalter is 'funny looking' as two prostitutes describe him, and that is the least you can say about Steve Buscemi. He plays a nervous nag who is partial to the *F word*. Silent Grimsrud loves pancakes and looks like the Marlboro man (or is that because he smokes so many Marlboro's?). His accent is as vague as his name, and he is a bit of a hothead. They have to kidnap their client's wife for a share of the ransom. However, when they are stopped by a policeman, Gaear simply shoots him (and two innocent passer-byers). They continue with the original plan, though the trail they are leaving makes it easy for detective Marge Gunderson to be on their heels.

Perhaps the most famous scene from *Fargo* is when Grimsrud beats his partner to death in a rage. Detective Gunderson catches him when he tries to throw Carl's body into a wood chip machine. We can see red coloured snow and Carl's foot, which still has a white sock on, sticking out of the cutting machine. It is a gruesome scene but the details make it extremely funny. Also the interaction between the quiet and ruthless Gaear and the anxious nattering Carl is entertaining to watch, especially when they are discussing pancakes.

1 5 10

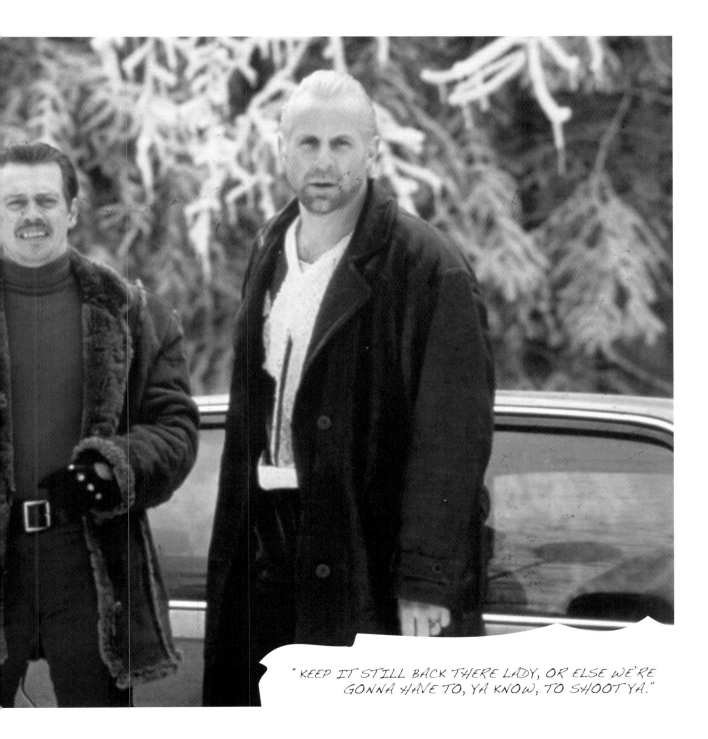

"KEEP IT STILL BACK THERE LADY, OR ELSE WE'RE GONNA HAVE TO, YA KNOW, TO SHOOT YA."

DANNY OCEAN
FRANK SINATRA

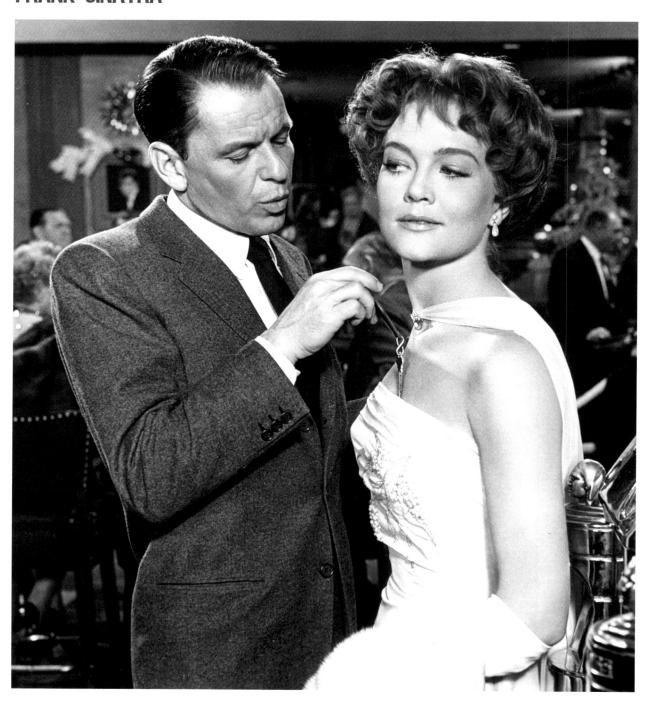

GEORGE CLOONEY

Ocean's Eleven (1960) – Lewis Milestone
Ocean's Eleven (2001), *Ocean's Twelve* (2004) en
Ocean's Thirteen (2007) – Steven Soderbergh.

Danny Ocean is what they call a gentleman thief. His is friendly, cool and especially charismatic. A man of few words who gets everything done. He is a villain, no doubt, but one we can sympathise with especially because the casino owners and competitors in the trade are anything but amiable. Danny can hardly be considered a rogue. He is the leader of a team which plays an important role in the films. In the 1960 version, this is the original Rat Pack; the later versions have an updated all-star cast, including Brad Pitt, Matt Damon and Don Cheadle, who bring Ocean great fame.

The films are not overly interesting. Everything is effortless and too easy. The secret lies in the dialogue, the jargon they use and the serious attitude they assume - as if they are not the fiddlers we see on screen. A couple of amusing examples: Ocean and Rusty (Brad Pitt) are meeting a client and talk some secret language. Linus (Matt Damon) wants to be part of the big boy's club but nearly messes everything up when he doesn't understand what they are saying; Rusty enters Ocean's hotel room where he finds him watching Oprah, weeping. They both become emotional when the hostess gives away a house to a family; one of the many jokes about Danny Ocean's age (as well as George Clooney's); Ocean who pours his heart out on a bridge in Amsterdam, when Rusty has long walked away; and lost lots more.

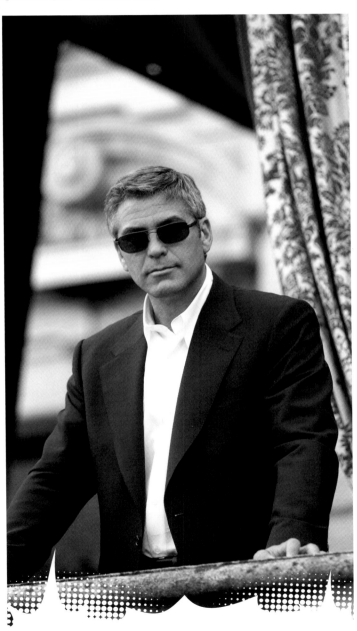

" I'M NOT SURE WHAT FOUR NINES DOES, BUT THE ACE, I THINK, IS PRETTY HIGH."

1 5 10

HARRY LIME & MARV MERCHANTS
JOE PESCI & DANIEL STERN

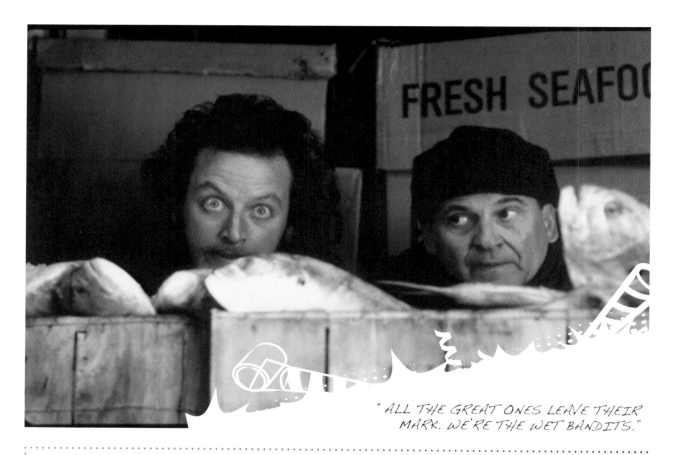

FRESH SEAFO

" ALL THE GREAT ONES LEAVE THEIR MARK. WE'RE THE WET BANDITS."

🎬 *Home Alone* (1990), *Home Alone 2: Lost in New York* (1992) - Chris Columbus

🏷 Harry Lime & Marv Merchants take themselves rather seriously, although they are of the clumsy thief variety. They break into houses when people are on holiday (and leave the tap running). Disguised as policeman, Harry goes door to door to find out more about days of departure and security systems. The house with the biggest jackpot seems to have no security in place, aside from Kevin McCallister (Macaulay Culkin), whom his parents have forgotten and who is therefore home alone: the rest is history... Harry is played by Joe Pesci, perfectly cast as the entertaining idiot. Daniel Stern is famous for this role, though it is his incredible scream that made the character immortal.

If the 'Kevin booby trap' slapstick does not make you laugh, then nothing will. A small selection of what is on offer: the frozen stairs that Harry and Marv fall down every time they want to enter the house, the iron that falls on Marv's face, the gas burner that shoots flames at Harry's hair, the hot doorknob, the spider, the pelting of bricks in *Home Alone 2* and last but definitely not least, Marv's electrocution. Talk about guilty pleasure!

1 5 10

JACQUES CLOUSEAU
PETER SELLERS

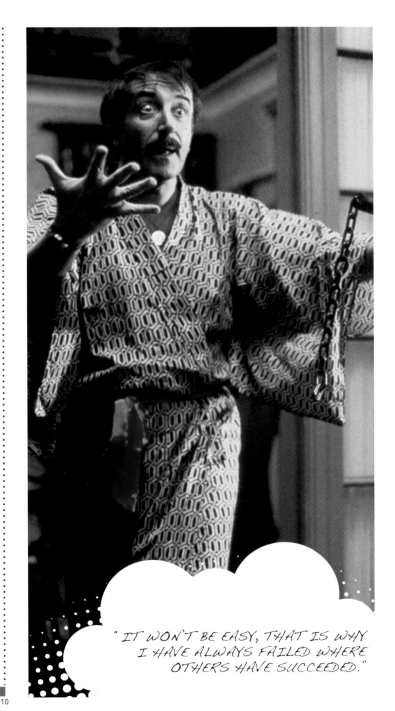

The Pink Panther (1963), A Shot in the Dark (1964), *The Return of the Pink Panther* (1975), *The Pink Panther Strikes again* (1976), *Revenge of the Pink Panther* (1978), *Curse of the Pink Panther* (1983) - Blake Edwards
Inspector Clouseau (1968) – Bud Yorkin
The Pink Panther (2006) - Shawn Levy, *The Pink Panther 2* (2009)

Additional actors: Alan Arkin, Roger Moore and Steve Martin

Inspector Clouseau mainly became famous when Peter Sellers took on the role. He is a French policeman and incredibly clumsy. Despite this distinguishing trait, he is promoted to chief inspector and seen by many as one of the most important French detectives (until they meet him). This is all thanks to the fact that he always resolves his cases (such as finding the legendary Pink Panther diamond) by accident. His enormous ego and belief that he really is a brilliant inspector make his clumsiness funny: he is adamant that he comes across sophisticated at all times, though he leaves a trail of destruction and enervates everyone in his path. Without him realising.

It is difficult to choose one classic moment from the numerous Clouseau films. Typical is his French accent ('ze phuun is in ze ruum') which became more and more exaggerated. Even funnier was when the French could not even understand him. Clouseau's Chinese helping hand, Cato, also livens things up. The inspector asks him to attack him at the most unexpected moments to train his reflexes and keep him on his toes. Although Clouseau pretends to be on top of it, Cato always manages to surprise him (by jumping out of the fridge for example) which causes great hilarity.

1 5 10

" IT WON'T BE EASY, THAT IS WHY I HAVE ALWAYS FAILED WHERE OTHERS HAVE SUCCEEDED."

JULES WINNFIELD & VINCENT VEGA
SAMUEL L. JACKSON ① & JOHN TRAVOLTA ①

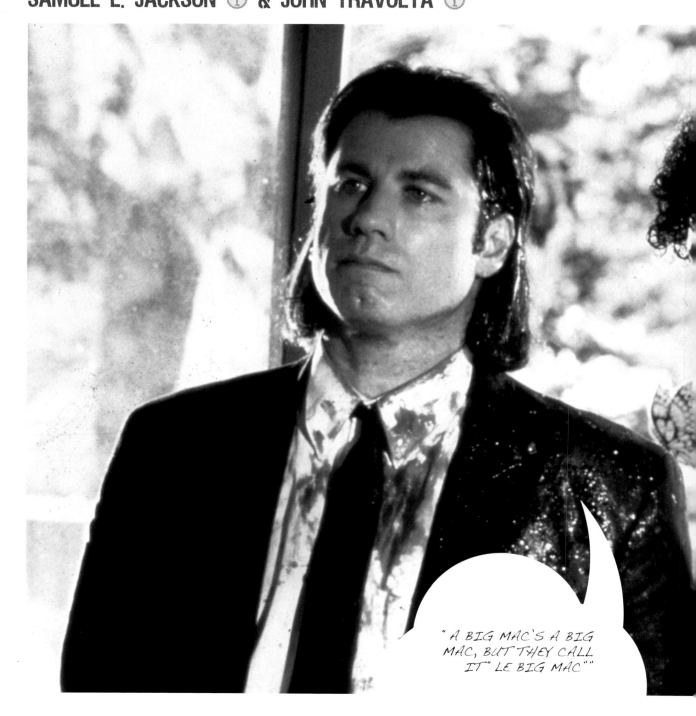

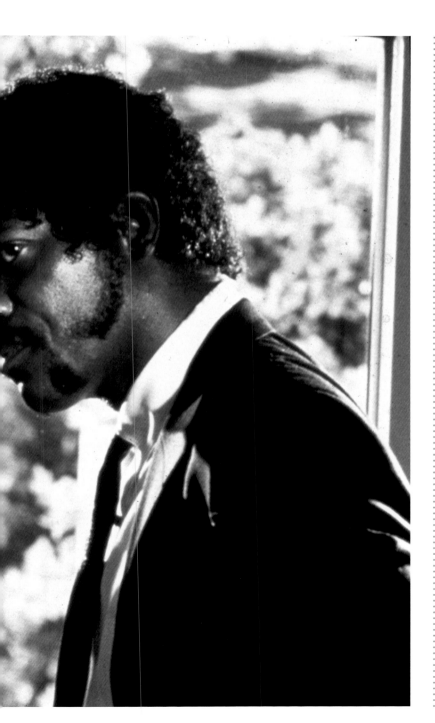

MARGE GUNDERSON
FRANCES MCDORMAND

📋 *Fargo* (1996) – Joel Coen

🏷️ Marge Gunderson is a police investigator from Brainerd, Minnesota (known for its foul weather). She is seven months pregnant and put in charge of a triple murder - a kidnapping that has gone wrong, ordered by the insignificant car salesman Jerry Lundegaard. Sprightly Marge is played by a genius and hilarious Frances McDormand (wife of director Joel Coen). Her common dialect *(Aw, geez!)* makes her sound rather silly, though she turns out to be the wittiest character in the film. She is determined and cheerfully follows her tracks according to the law.

📺 Her typical accent and enthusiasm make everything she says fascinating. Comical are the interrogation of the two prostitutes *(Yah!)* and Jerry Lundegaard (William H. Macy). Unforgettable is the scene when Marge is overwhelmed by morning sickness when she inspects the scene of crime. Truly worth remembering is the arrest of one of the kidnappers at the end. Those are the most beautiful and wise words in the entire film and if you hadn't taken her into your heart by now, this is the time!

1 5 10

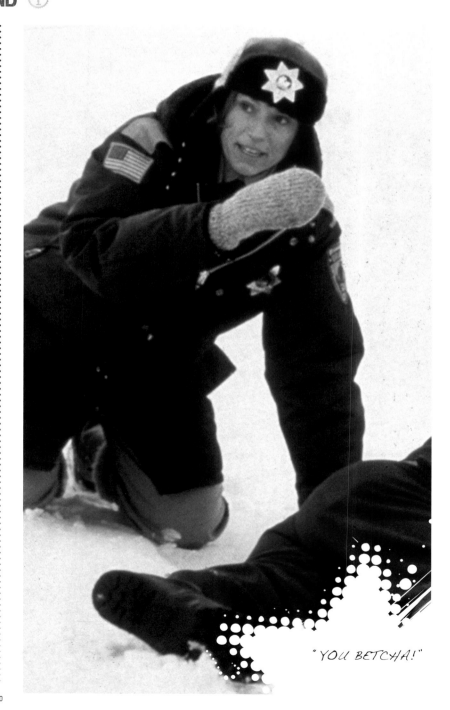

"YOU BETCHA!"

MARTY MCFLY
MICHAEL J. FOX

📋 *Back to the Future* (1985), *Back to the Future Part II* (1989), *Back to the Future Part III* (1990) - Robert Zemeckis

🏷️ Marty McFly is 17 years old and best friend of Dr. Emmett Brown (Christopher Lloyd), a nutty professor who has built a time machine in the shape of a DeLorean. In the first film, Marty is zapped back to 1955 where his own mother falls in love with him. As a result, his father is left out of the picture and his own existence, and that of his siblings, is at risk. He tries everything to bring his parents together, but what he changes in the past will have consequences in the present time. Marty is not a brainbox but is brave when he needs to be and will do anything for his friends. He will do the most stupid things to prove that he is no coward. When someone calls him a '*chicken*', he loses the plot.

⚓ A franchise like this provides repeated and recognisable moments, such as the skateboard scene and numerous phrases. Marty's appearance at the school party in 1955 is also quite remarkable. He plays *Johnny B. Goode* on guitar but goes a little wild during his solo: the past is clearly not ready yet for 1985 music. Funny are Marty's names in the past. In the first film, he is called Calvin (as a result of his *Calvin Klein* pants). When he is asked his name in the third film, which takes place in the Wild West, he replies: "*Eastwood. Clint Eastwood*".

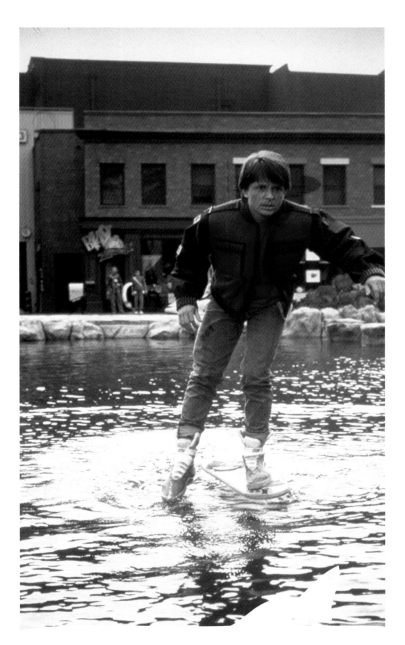

" ARE YOU TRYING TO TELL ME THAT MY MOTHER HAS GOT THE HOTS FOR ME?"

1 5 10

SUPER GOOD AND SUPER BAD

The masked hero, the saviour of the day. Everything about him is super: his suit, style, powers, girlfriend, sidekick, alter ego and especially his enemy. The superhero comic is for many the ultimate film experience. The necessary special effects, the world in danger, the dubious state of the hero, his personal struggles, the jokes, costumes and antagonists. The enemy must be truly evil in order to make our hero's life difficult. And truly mad. We all enjoy the Joker's cutting capers, the mysteries of Clark Kent and Spiderman's rescue operations. And when times are bad, we may even be tempted to call out to heaven and repeat Homer Simpson's words: *'I'm not normally a praying man, but if you're up there, please save me Superman!'*
This chapter looks at the classic icons in the world of comics, strong men with a secret and women whose superpower is their sex appeal.

 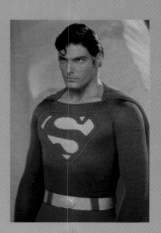

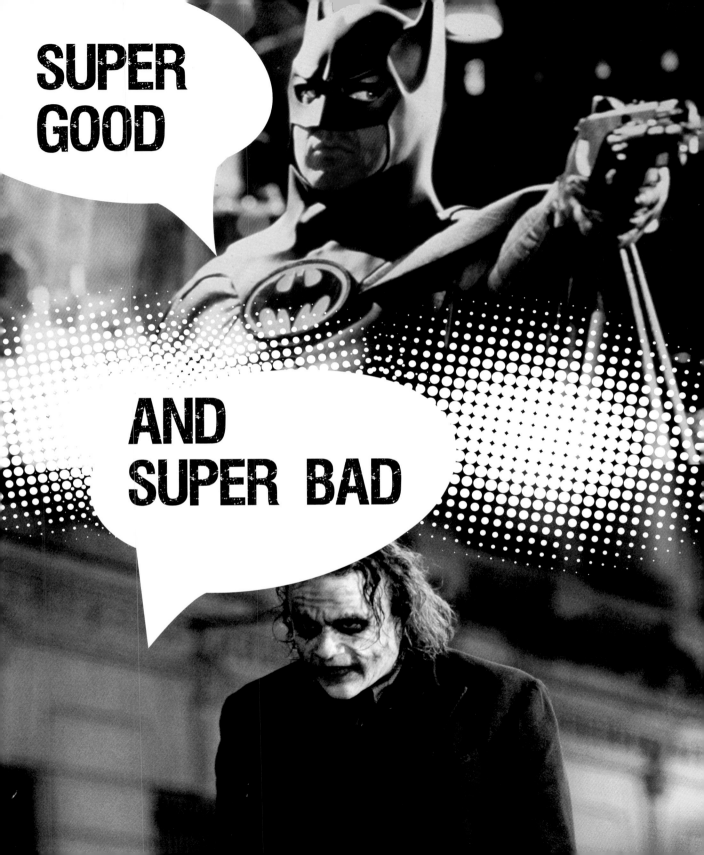

BARBARELLA
JANE FONDA

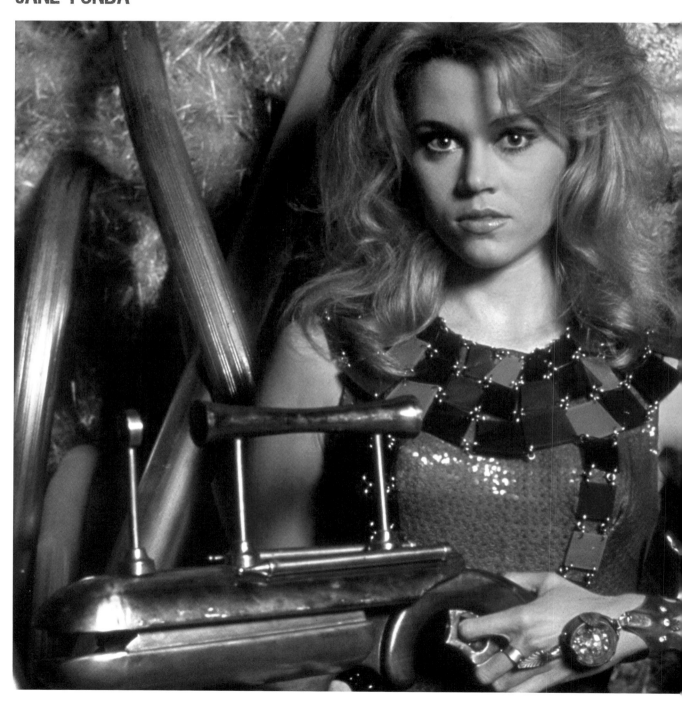

" A GOOD MANY DRAMATIC SITUATIONS BEGIN WITH SCREAMING."

 Barbarella (1968) – Roger Vadim

Barbarella is a French comic heroine who has rather sexual adventures and who was brought to life in the '68 film by Roger Vadim, starring his wife at the time, Jane Fonda. The film was simultaneously shot in French and English (both recorded by Fonda). Barbarella is assigned by the President of Earth (where people have been living in peace for centuries) to go to the planet SoGo and find the dangerous scientist Durand Durand. On her journey, she meets the weirdest creatures, frequently loses her clothes and finds out what sexual pleasure is (which no longer exists on earth in its original form).

The most controversial scene in the film is its opening sequence where Barbarella floats around in a vacuous space and takes off her space suit until she is completely naked. The opening credits fail to fully cover her... The other sex scenes are less explicit but frequent in number. Everyone remembers Durand Durand's *Excessive Machine*. This is an orgasmic instrument in the shape of an organ that delivers sexual pleasure in doses that can be lethal. Barbarella overloads the machine and is visibly disappointed when the 'torture' stops. Also worth remembering are the psychedelic elements and camp decors, costumes and acting.

1 5 10

BATMAN / BRUCE WAYNE
ADAM WEST

"BATS FRIGHTEN ME. IT'S TIME MY ENEMIES SHARED MY DREAD."

BRANDON ROUTH

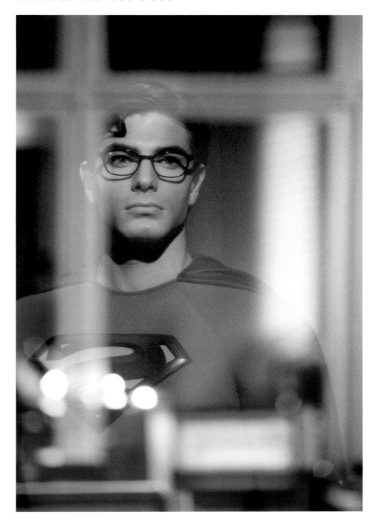

🎬 *Superman* (1978) – Richard Donner, *Superman II* (1980) – Richard Lester, *Superman IV: the Quest for Peace* (1987) – Sidney J. Furie *Superman Returns* (2006) – Bryan Singer

🏷 Christopher Reeve, an unknown actor at the start of filming, is the real Superman, a true personification of the *Action Comics* hero. He is superhumanly fast and strong, can fly, has perfect hearing and X-ray vision. The man of steel has to disguise himself as Clark Kent to live amongst people. The parting of his hair is different, he wears glasses and he doesn't have a mask like some superheroes, yet no one recognises him. Quite incredible, not? Reeve is as convincing in the part of clumsy Clark, as in that of self-confident superhero. As he ruthlessly trained during the filming, he had to retake certain scenes for continuity sake (by then the size of his biceps had doubled). Brandon Routh positively comes out of Reeve's shadows even though he is hard to replace.

📷 Some of the most classic moments of the ultimate hero come from the first *Superman* film. First on the list are his comical interview with Lois Lane on her roof terrace (including a joke about her panties, always amusing) and subsequently the romantic flight (with an incredible voice-over by Lois). Secondly, the nearly blatant winks from Clark at the camera ('you know that it's me...'), for example when he saves Lois from a bullet or is able to sum up the content of her handbag. We see his human side when, against the will of his father (Marlon Brando as Jor-El), he turns back the time by flying around the earth to save Lois life.

1 5 10

ZORRO

DOUGLAS FAIRBANKS

The Mark of Zorro (1920) – Fred Niblo, *Don Q, Son of Zorro* (1925) – Donald Crisp
Zorro's Fighting Legion (1939) – John English
The Mark of Zorro (1940) – Rouben Mamoulian
The Sign of Zorro (1958) – Lewis R. Foster,
Zorro the Avenger (1959) – Charles Barton
The Mask of Zorro (1998), *The Legend of Zorro* (2005) – Martin Campbell

Additional actors: Reed Hadley, Tyrone Power Guy Williams and Anthony Hopkins

Zorro (Spanish for 'fox') came to life in 1919 when tabloid writer Johnston McCulley created a hero for the eight year old boy inside all of us. He is the alter ego of the clumsy and cowardly Don Diego de la Vega (with small moustache) from Spanish speaking California. Disguised in black costume with cape, hat and mask, he goes to battle against the tyranny on his horse Tornado. He takes the law into his own hands: outlaw and public hero. He takes after Robin Hood and the by him inspired Batman – Bruce Wayne went to see *The Mark of Zorro* with his parents. Zorro refrains from brute force and uses acrobatics and elegance, which makes him rather popular with women. His trademark is the 'Z' which he leaves on walls or in curtains or clothes with his sword or whip.

We mainly remember Zorro for his roguish moments, as well as the thrilling duels. The man-to-man fight between Don Diego and Esteban Pasquale (Basil Rathbone) in *The Mark of Zorro* (1940) is perhaps the most legendary sword fight in film history: two talented fencers who face each other in a fabulously choreographed scene with a fatal ending. The duel between Antonio Banderas and Catherine Zeta-Jones in *The Mask of Zorro* is nowhere near of the same level but it does lead to a passionate kiss. And this always works: the hero and the girl who start with a fight but later let passion take over.

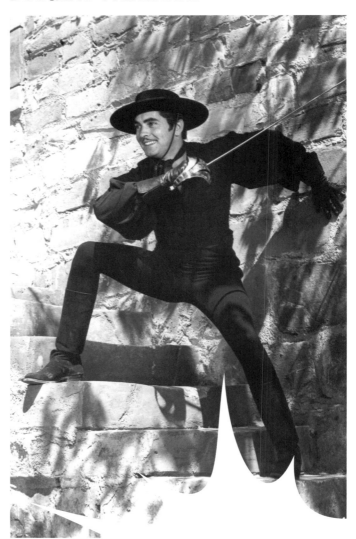

"THE POINTY END GOES INTO THE OTHER MAN."

1 5 10

ANTONIO BANDERAS

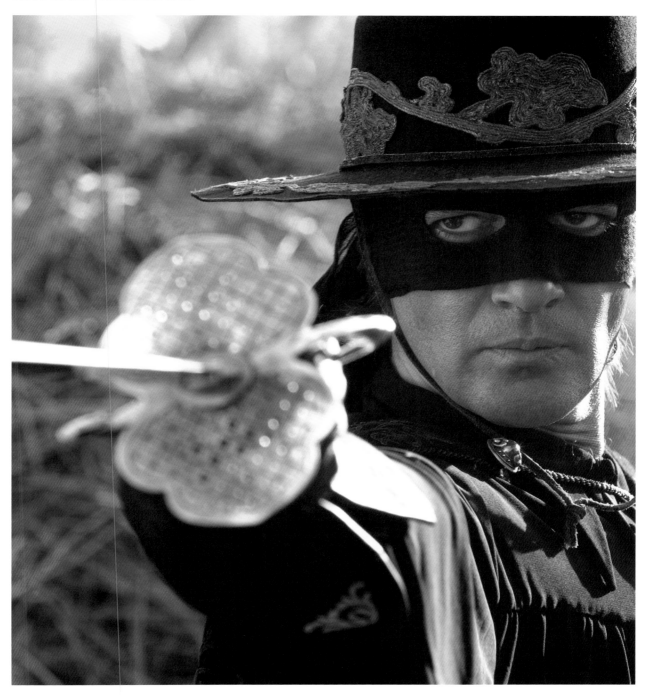

FANTASY AND HORROR

Characters from a fantasy world, blood-curdling creatures or fantastic figures that have appeared in our society or our dreams: the most heroic saviours and horrifying monsters. Our imagination has no limits and allows us to get fully lost in it. As they sometimes seem to come from an entirely separate universe, they are difficult to categorise. Therefore, this chapter contains the most fearless heroes and meanest creatures. Dressed in large gowns, tight tights, or fully transformed, with a wink at the audience or extreme seriousness. The victims of the horror villains die in the most atrocious circumstances and the heroes are even more heroic because of the incredible evil they are able to defeat. Fact is that we will not easily forget this mish mash of creatures not in the least because they continue to haunt us at night.

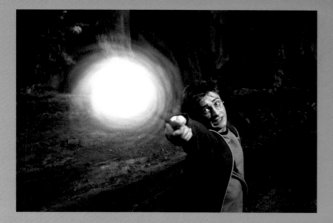
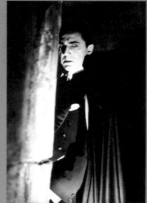
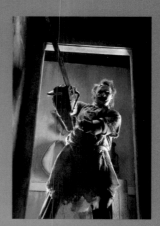

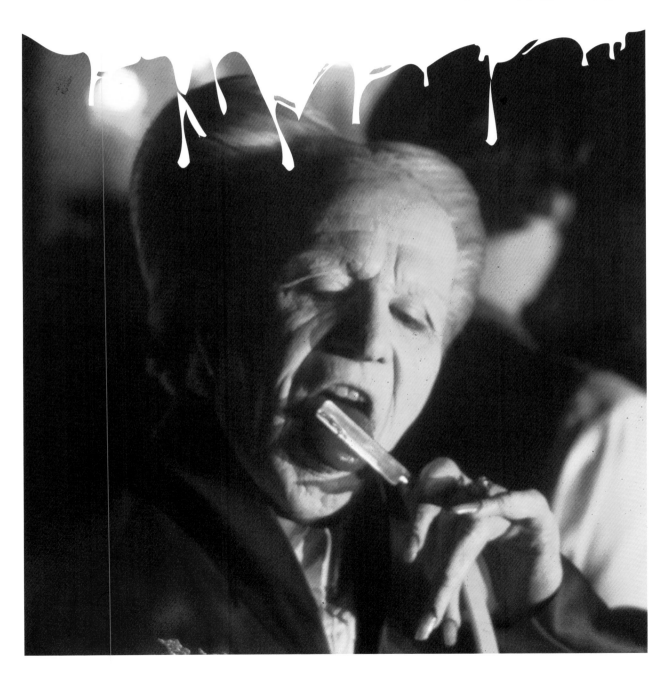

GARY OLDMAN

" I NEVER DRINK ... WINE.

DAMIEN THORN
HARVEY STEVENS

" LOOK. THERE'S NANNY."

SEAMUS DAVEY FITZPATRICK

The Omen (1976) – Richard Donner
Damien: Omen II (1978) – Don Taylor
The Final Conflict (1981) – Graham Baker
The Omen (2006) – John Moore

Additional actors: Jonathan Scott Taylor and Sam Neill

Robert Thorn (Gregory Peck), an American ambassador, adopts, without his wife knowing, a son after her miscarriage (at 6am on the sixth day of the sixth month - get the drift?): Damien Thorn is the Antichrist and Satan's child. When young Damien (sounds like demon) turns five, a demonic rottweiler appears and his nanny hangs herself. From then on, things spiral downhill. At first, Robert does not believe the omens but after his wife, a crazy priest and a friend photographer die a gruesome death, he wants to kill the devil's child. In an attempt to do so he is shot by the police and Damien is adopted by the US President. The devil is one step closer to the Apocalypse (shown in the two sequels and the 2006 remake)...

Although Damien is without doubt the Antichrist – proof are the 666-shaped birthmark on his skull, his dark hair and creepy suit (who dresses his child like that?) – he is not in for much more than casting some baleful looks into the camera and laughing sinisterly. The real atrocities are taken care of by supernatural powers or 'accomplices' like his scary nanny. The only murder he is responsible for is that of his mother's unborn child when he runs her over on his trike and she falls from the first floor. The most notorious scene of all is when his first nanny hangs herself at his birthday party with the words 'Look at me Damien! It's all for you!'. Also important are the omens in the photos: strange shadows display how the characters will die.

1 5 10

FREDDY KRUEGER
ROBERT ENGLUND

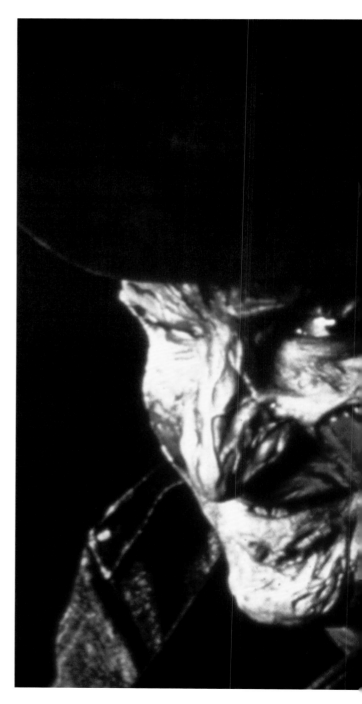

Nightmare on Elm Street (1984) – Wes Craven, *Nightmare on Elmstreet 2: Freddy's Revenge* (1985) – Jack Sholder, *Nightmare on Elmstreet 3: Dream Warriors* (1987) – Chuck Russell, *Nightmare on Elmstreet 4: The Dream Master* (1988) – Renny Harlin, *Nightmare on Elmstreet 5: The Dream Child* (1989) – Stephen Hopkins, *Freddy's Dead: The Final Nightmare* (1991) – Rachel Talalay, *New Nightmare* (1994) – Wes Craven, *Freddy vs. Jason* (2003) – Ronny Yu
A Nightmare on Elm Street (2010) – Samuel Bayer

Additional actor: Jackie Earle Haley

Although Freddy Krueger is a child murderer who is acquitted of charges but later killed by the parents, he has a bubbly personality and humour which makes him into one of the most popular horror characters ever. He spooks around his victims nightmares with his burned and disfigured face, red and green striped sweater and brown hat. His trademark is a razor-clawed glove to kill teenagers within their dreams, which results in their deaths in the real world. As he is a dream stalker, he has unlimited power. He is able to transform himself and move around as he pleases. The film explores a universal fear: one has to sleep. What happens when someone takes advantage of this extremely vulnerable state, in which we cannot defend ourselves? Krueger can be defeated when pulled into the real world (and standing up to him), where he has normal human vulnerability and strength.

When his potential victims are dreaming of rope-skipping children who sing a rhyme about Freddy, or when we hear the tune in the background, we know something horrible is about to happen. Another ominous sound which follows the teenagers, even when they are awake, is the screeching of Freddy's blades on the walls. In the first film alone, there are a number of funny though terrifying moments, such as Freddy's hand in Nancy's bath, a very young Johnny Depp spouting fountains of blood and naturally, Tina's murder. She gets slaughtered by, to us and her helpless boyfriend, an invisible Freddy who makes her see all corners of the room in her underwear, when she is most vulnerable. The walls become increasingly more stained with blood until she finally crashes down back onto the bed, dead.

1 5 10

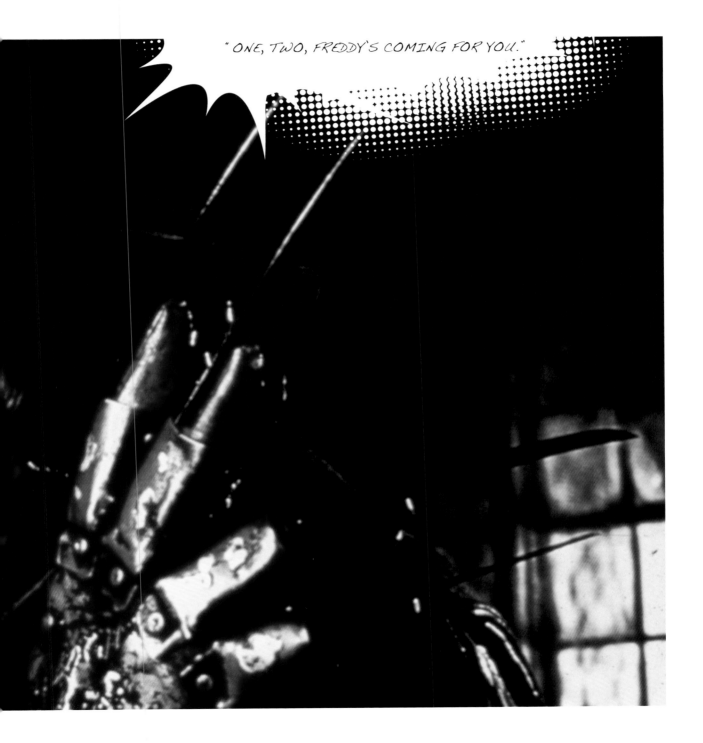

GANDALF
IAN MCKELLEN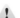

🎬 *The Lord of the Rings* (1978) -
Ralph Bakshi
The Lord of the Rings: the Fellowship of the Ring (2001), *The Lord of the Rings: the Two Towers* (2002), *The Lord of the Rings: the Return of the King* (2003) – Peter Jackson

Additional actor: William Squire

🏷 Gandalf is like a friend from the past: *The Lord of the Rings* by Tolkien is inspired by ancient tales and was an inspiration to many authors and filmmakers. The wise man and mentor is how we picture a wizard to be. Gandalf is however, not your average wizard. Agreed, he has a beard and a long grey robe (until he returns from death as 'the White'), he has a magic walking-stick, the deep voice of Ian McKellen and he literally knows everything. But he is also funny and good-natured. He loves life and lives hard, in all its ways: he is determined and caring, shows his emotions and amazement, and has a cheeky sense of humour. Every character has its place but it is Gandalf that joins them together. Although he too is scared of the Ring, we can relax when Gandalf is around.

🎞 We heave a sigh of relief when Gandalf (the White one on this occasion) appears to still be alive after his fascinating fight with the Balrog, a fiery demon. Things get even better when we see him riding his white horse Shadowfax, going into battle with a full army back-up. Slightly worrying is when Gandalf fights his old mentor. One thing is clear: Gandalf is capable of anything, and has no problem protecting Frodo and Aragorn, and Harry from Voldemort. Or was that the other white bearded wizard?

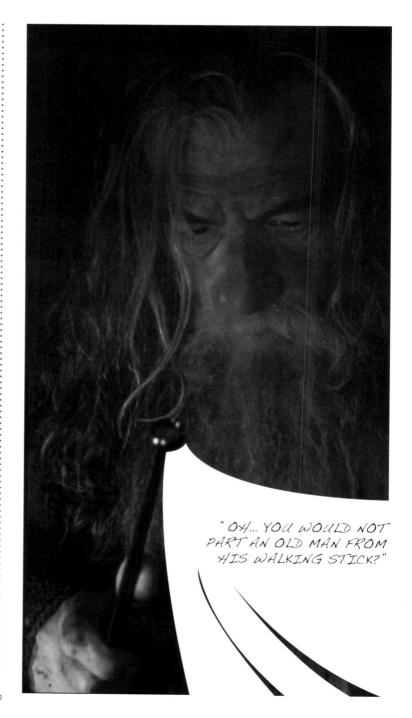

" OH... YOU WOULD NOT PART AN OLD MAN FROM HIS WALKING STICK?"

1 5 10

GHOSTFACE
ROGER JACKSON, SKEET ULRICH & MATTHEW LILLARD

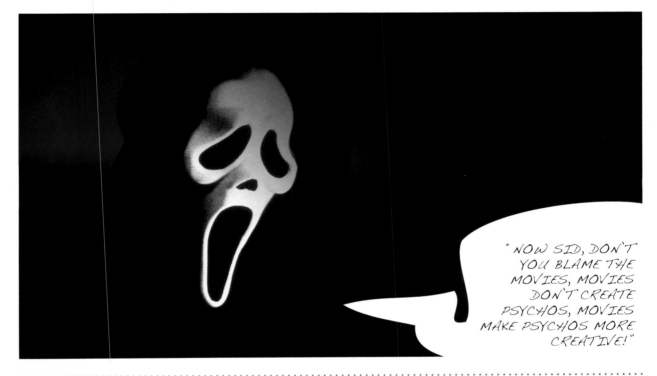

" NOW SID, DON'T YOU BLAME THE MOVIES, MOVIES DON'T CREATE PSYCHOS, MOVIES MAKE PSYCHOS MORE CREATIVE!"

🎬 *Scream* (1996), *Scream 2* (1997), *Scream 3* (2000), *Scre4m* (2011) - Wes Craven

Additional actors: Timothy Olyphant, Laurie Metcalf and Scott Foley

🏷 *Scream* and his villain rapidly turned into an icon. The character in its black robe with the mask based on the painting *The Scream* by Edward Munch has become such a familiar sight, it no longer gives you the heebie-jeebies. However, the first time you see 'Ghostface', it does freak you out. The murderer, as well as the film actually, was rather progressive: he used a mobile phone, which according to director Wes Craven was unprecedented, and he was clever. He is not a brainless barbarian who randomly kills people. He seems to have a plan which gives you the creeps even more. It is a shame that we always find out who is behind the mask – *Scream* is simply a bloody whodunit but the appearance of 'Ghostface' is much more interesting. The secret perpetrators (more than one!) are often incredible and hysterical.

The first scene from the first *Scream*, when Drew Barrymore (similar to Janet Leigh in *Psycho*, the biggest star of the film) is terrorised and turned inside out by the man in the mask, is world-famous. The scene is put into scene again in the sequels by actors in the 'film within the film' *Stab* about the events in *Scream*. Still with me? As becomes clear from the quiz questions about horror films asked by the murderer to his victims, the entire 'thrillogy' brims over with self-knowledge: youngsters talk about the rules to stay alive in horror films, they use film related locations such as video shops, cinemas and sets, and references to other films, actors and characters are made. In short, *Scream* is unique. It is a parody which is both funny and thrilling.

1 5 10

GOLLUM
ANDY SERKIS

The Lord of the Rings (1978) –
Ralph Bakshi
The Lord of the Rings: the Fellowship of the Ring
(2001), *The Lord of the Rings: the Two Towers*
(2002), *The Lord of the Rings: the Return of the King* (2003) – Peter Jackson

Additional actor: Peter Woodthorpe

Gollum is a creature from Middle-earth, created by author J.R.R. Tolkien in his trilogy *The Lord of the Rings*. Gollum used to be a hobbit, Sméagol, who killed his friend Déagol when he refused to give him the Ring he found when out fishing. From then on, his life extends far beyond its natural limits by the effects of possessing the evil Ring which turns him into the character we know from the films played by Andy Serkis: stooped, pale with frog-like eyes and a split personality, making horrible noises in his throat (which is where he gets his name from). When Bilbo Baggins steals the ring, the only goal in Gollum's life is to retrieve it. He travels all across Middle-earth until he becomes Frodo's guide.

Rapidly integrated into popular culture, there are many noteworthy scenes from Gollum. We remember the sequence when Sméagol transforms into the monster Gollum as a result of the years of influence of the Ring. A scene that is often adapted is when Gollum's good and bad personalities quarrel in their own language about the destiny of hobbits Sam and Frodo. However, the most important scene of all takes place after the fight with an invisible Frodo, when he bites off his finger and falls – over the moon because he finally has his precious Ring back – in *Mount Doom*. Lucky that other characters previously had had too much sympathy with him to kill him. He was destined to finish off the task that Frodo was unable to complete: destroy the ring in the fire that forged it.

1 5 10

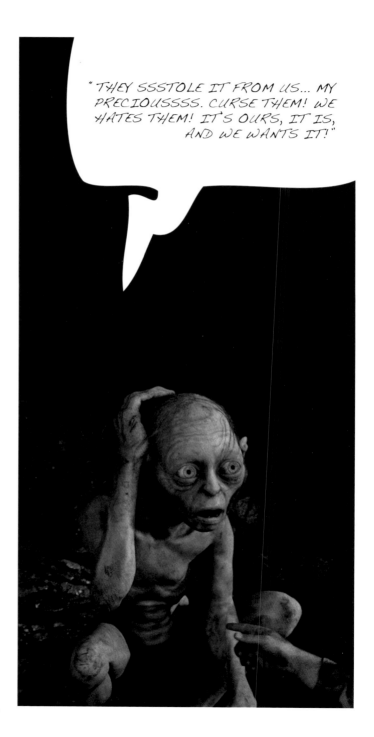

"THEY SSSTOLE IT FROM US... MY PRECIOUSSSS. CURSE THEM! WE HATES THEM! IT'S OURS, IT IS, AND WE WANTS IT!"

HARRY POTTER
DANIEL RADCLIFFE

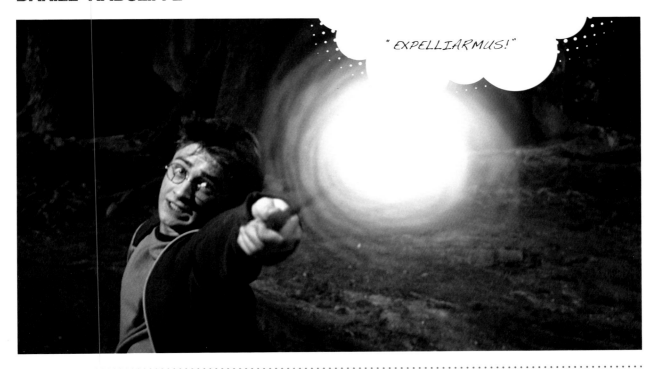

" EXPELLIARMUS!"

Harry Potter and the Sorcerer's Stone (2001), Harry Potter and the Chamber of Secrets (2002) – Chris Columbus, Harry Potter and the Prisoner of Azkaban (2004) – Alfonso Cuarón, Harry Potter and the Goblet of Fire (2005) – Mike Newell, Harry Potter and the Order of the Phoenix (2007), Harry Potter and the Half-Blood Prince (2009), Harry Potter and the Deathly Hallows part I (2010), Harry Potter and the Deathly Hallows part II (2011) – David Yates

A teenage wizard with glasses, two friends and an evil enemy. That is Harry Potter in a nutshell. He is obviously much more than that, judging by his flocks of fans – who don't usually entirely agree with the film version of the popular books by J.K. Rowling. Daniel Radcliffe was the lucky one to be cast as the student wizard, and although he grows faster than his character, he stages a good balance between the innocence of an adolescent and his major responsibilities. He is destined to defeat evil, and although he can count on his mentor and friends, he is alone in his fight.

In the first film, everything is new as we can see from the sparkle in Harry's eyes. We are introduced into the world of magic which is exciting and unforgettable. The films become more dark and gripping but we seem to have lost the endearing innocence of our hero. Perhaps rather disheartening, yet the most memorable scenes are those when Harry witnesses the death of another character, it being Cedric Diggory, Sirius Black or Dumbledore. And because it is entertaining: a fun game of quidditch or bickering with Professor Snape. That's entertainment!

1 5 10

LEATHERFACE
GUNNAR HANSEN

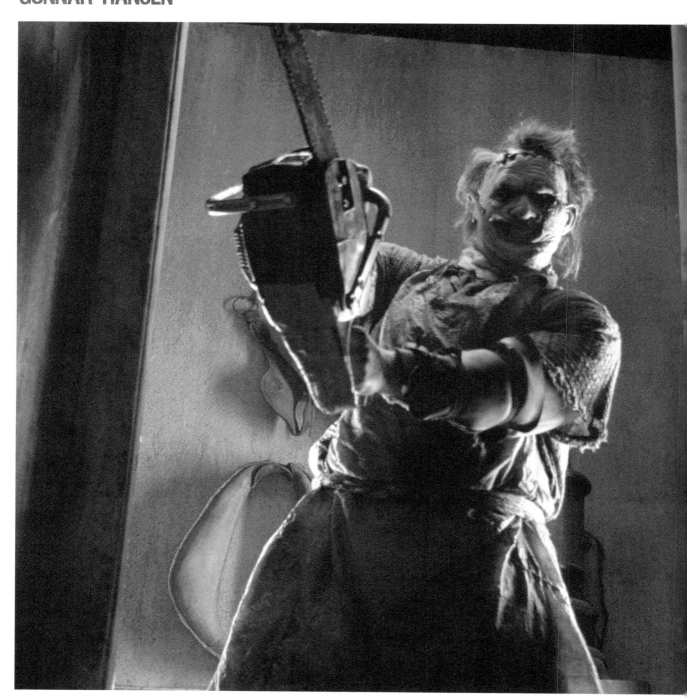

"WHAT'S THAT STENCH?"

The Texas Chainsaw Massacre (1974) – Tobe Hooper
The Texas Chainsaw Massacre 2 (1986) – Tobe Hooper
The Texas Chainsaw Massacre (2003) – Marcus Nispel,
The Texas Chainsaw Massacre: the Beginning (2006) –
Jonathan Liebesman

Additional actors: Bill Johnson and Andrew Bryniarski

The Texas Chainsaw Massacre looks like a
documentary, not only because of the images but also,
and mainly, due to the realistic sounds (for example, the
thud when bashing someone's brains in, or twitching feet
on the floor). Atypically, the film portrays the murderers
rather than the victims. Leatherface is a large man with a
mask made of human skin (as he is mute, he has three
different ones to express his moods). He is frightening
because there is no personality under the mask. Although
the chainsaw (which never seems to run out of fuel) adds
a little to the effect. He is not clever but a skilled butcher,
and is under the influence of his crazy family of grave
robbers and cannibals, who use the bones of his victims to
decorate the house and process the flesh into barbeque
sausages.

Considered to be one of the bloodiest *slasher films*
in history, it is perhaps surprising that much of the
goriness takes place off-screen or behind closed doors.
This doesn't take away from the fact that we spend half of
the time with our eyes closed. The first appearance of
Leatherface, in the doorway, is even traumatic. He knocks
his victim down, drags him into another room and shuts
the metal door. We can only guess what happens next,
though we sadly find out later. The end of the film is also
legendary: Sally escapes by jumping into a lorry.
Leatherface is furious because she escaped but he is
unable to voice his anger. He expresses his feelings by,
what seems like, dancing into the sunset with his
chainsaw.

1 5 10

PETER PAN
ROBIN WILLIAMS

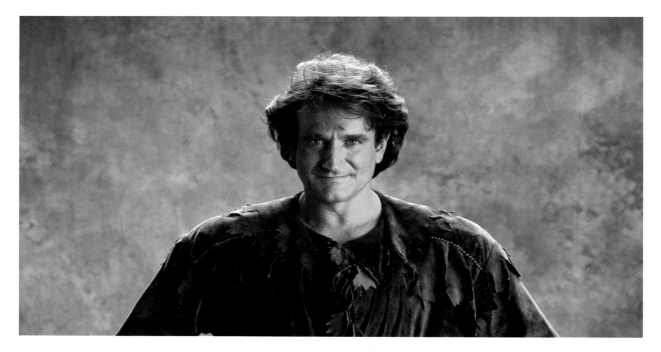

🎬 *Peter Pan* (1924) - Herbert Brenon
Peter Pan (1953) - Clyde Geronimi, Wilfred Jackson
Hook (1991) - Steven Spielberg
Peter Pan (2003) – P.J. Hogan

Additional actors: Betty Bronson and Jeremy Sumpter

🏷️ Peter Pan (created by J.M. Barrie in 1904) is more or less based on the mythological god Pan. He is a mischievous boy who refuses to grow up and spends his never-ending childhood on the island of Neverland, in the company of the Lost Boys, mermaids, Indians, pirates and the fairy Tinker Bell. He literally is cock of the walk and crows to his heart's content. Using happy thoughts, he is able to fly and he is also top of the class in duelling (as he proves when chopping off Captain Hook's hand). Disney makes the characters more caricatural which is not surprising for a cartoon. *Hook* wonders what would happen if Peter were to grow up. The 2003 film is full of youthful enthusiasm, boyish charm and exciting tales, yet it does not disregard the darker side of melancholy and fear, as Barrie probably intended.

📺 Little children want to be Peter Pan. He dances with Indians, fights with pirates, swims with mermaids but most impressively: he can fly. The best scene in nearly every film version is when he teaches the Darling children to fly after Wendy has caught his shadow; something else that draws curiosity. The story is not only entertaining, it is shamelessly touching. The lost boys think that Wendy is their surrogate mother and ask her what a mother really is. Then we realise that being Peter Pan isn't all fun and games and that, rather than having the most exciting adventures, it is sometimes nicer to be read a bedtime story by your mummy.

1 5 10

BOBBY DRISCOLL

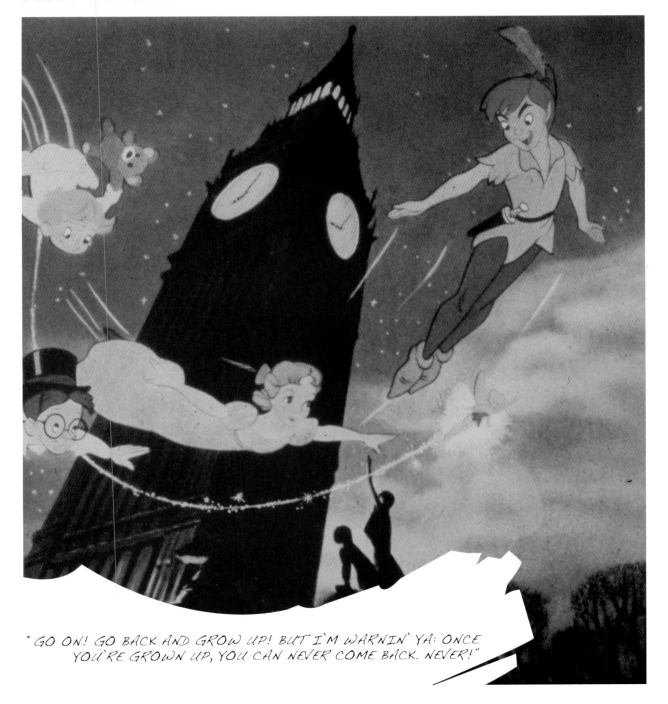

"GO ON! GO BACK AND GROW UP! BUT I'M WARNIN' YA: ONCE YOU'RE GROWN UP, YOU CAN NEVER COME BACK. NEVER!"

SWEENEY TODD

JOHNNY DEPP ⓘ

⚠

🎬 *Sweeney Todd* (1928) – Walter West
The Demon Barber of Fleet Street (1936) –
George King
*Sweeney Todd: The Demon Barber of Fleet
Street* (2007) – Tim Burton

Additional actor: Tod Slaughter

🏷 Horror legend Tod Slaughter played the
original Sweeney Todd as a psychopath driven
by greed. In the famous musical version by
Stephen Sondheim, he is given a badly treated
alter ego, Benjamin Barker, which turns Todd
into more of an antihero, who is out to get
revenge. Depp's rendition of Sweeney, with his
white lock of hair, is heartless, as are nearly all
of the other characters in this pessimistic and
hope bereft horror musical that happily smears
some more red paint around. The actors don't
sing at the top of their voices but sing more to
themselves and each other than the audience
(atypical for a musical). Out for revenge on the
evil judge, barber Todd first kills quite a number
of innocent victims who, after slitting their
throats, are dispatched via a revolving trapdoor
into the basement of Mrs Lovett (Helena
Bonham Carter) where she bakes their flesh
into meat pies that she sells in her shop.

🎬 The only truly amusing moment (if you
ignore the morbid humour in the rest of the
film) is when Sweeney Todd and the charismatic
Pirelli (Sacha Baron Cohen) face each other in a
barber competition which inevitably leads to
his death. Also quality: when, after living in exile for
years, the barber finds his old razor blades
again, and therefore part of himself. The
sparkling chemistry between Depp and Bonham
Carter shows in their duets, in which they
fantasise about the choice of meat they will use
in the meat pies (priest or poet?).

1 5 10

MOORE MARRIOTT

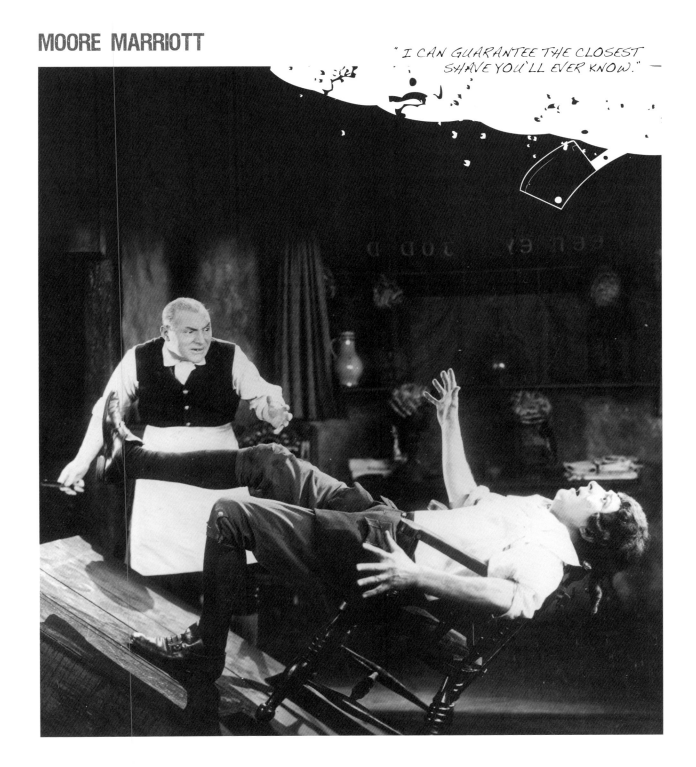

VOLDEMORT
RALPH FIENNES

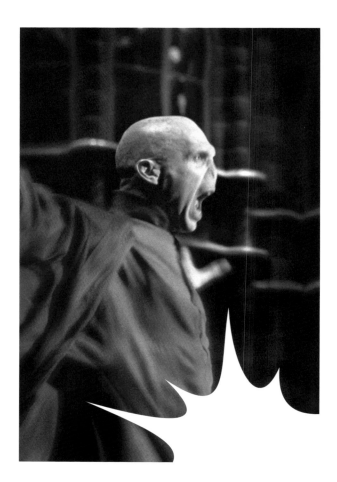

⚠️

📽️ *Harry Potter and the Sorcerer's Stone* (2001) - Chris Columbus, *Harry Potter and the Chamber of Secrets* (2002) – Chris Columbus, *Harry Potter and the Goblet of Fire* (2005) – Mike Newell, *Harry Potter and the Order of the Phoenix* (2007), *Harry Potter and the Half-Blood Prince* (2009), *Harry Potter and the Deathly Hallows part I* (2010), *Harry Potter and the Deathly Hallows part II* (2011) – David Yates

Additional actors: Richard Bremmer and Christian Coulson

🏷️ 'I am Lord Voldemort' is an anagram of Tom Marvolo Riddle, the birth name of Harry Potter's archenemy, also known as 'You-know-Who', 'He-who-must-not-be-named' or 'the Dark Lord'. He is a powerful wizard, who believes in a pure-blood race, (although he was a half-blood himself) and builds an army to fight the Muggles. Sound familiar? Voldemort and the books and films that he appears in show parallels with reasonable current political developments, not least the Second World War and Nazism. His main weaknesses are the inability to feel compassion or love, and his intemperate fear of death. The latter has made him split his soul into seven *horcruxes*. He can only die when all of them are destroyed. Rather annoying is the unwished for connection with young Harry who carries one of the horcruxes in him.

🎬 The most fascinating moment from the many films and books about Harry and Voldemort is the 'resurrection' of 'You-Know-Who' in *The Goblet of Fire*. Voldemort regains his body (pale, long fingers, looking like a snake) after a spell that required Harry's blood and the flesh of a servant amongst other things. He kills a student, is joined by his servants (*Death Eaters*) and realises again that Harry is not easily beaten. Severus Snape (Alan Rickman) deserves a special mention as the teacher who is constantly portrayed as the baddie and servant of Voldemort but who eventually turns out to be a good spy, and protector of Harry.

"THERE IS NO GOOD AND EVIL. THERE IS ONLY POWER...AND THOSE TOO WEAK TO SEEK IT."

1 5 10

WICKED WITCH OF THE WEST
MARGARET HAMILTON

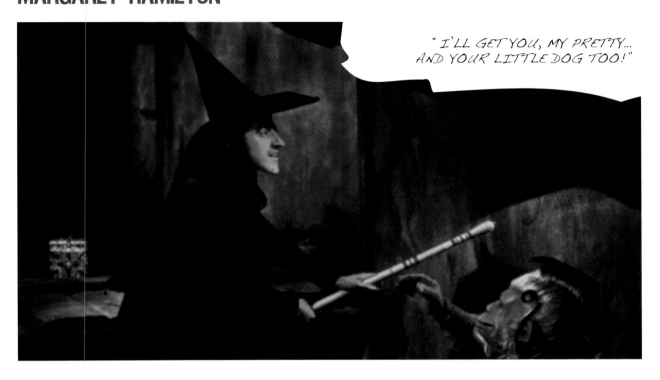

" I`LL GET YOU, MY PRETTY...
AND YOUR LITTLE DOG TOO!"

The Wizard of Oz (1939) - Victor Flemming
The Wiz (1978) – Sidney Lumet

Additional actress: Mabel King

The Wicked Witch of the West is the biggest threat to Dorothy Gale (Judy Garland) during her trip to the Wizard of Oz. It so happens that the witch is after her magical red shoes that used to belong to her sister, the Wicked Witch of the East, before Dorothy accidentally killed her when crashing down with her house. If the Tin Woodman, the Scarecrow and the Cowardly Lion all represent child fears, the evil witch is no different. Her crooked nose, warts, green skin, black clothes, broom and pointed hat make her into an archetype. On top of that, she has the most bloodcurdling screech and is not averse to torturing small dogs. In the Technicolor coloured Land of Oz (created by author L. Frank Baum), she wants to enslave everyone, like her army of Winged Monkeys.

As Dorothy travels through the Land of Oz, she is constantly chased by the wicked witch. The viewer is reminded of this at all times. We regularly see her appear from behind a tree, flying on her broom or looking into her crystal ball. Also entertaining is the first time she arrives in a red cloud - Margaret Hamilton suffered serious burns to her hands and face when filming one of these scenes. Though most memorable is her unexpected death scene where she melts when Dorothy accidentally throws a bucket of water over her.

1 5 10

SCIENCE FICTION

The future - or the past, in a galaxy far away - is a black hole, an intangible universe which we love to fantasize about. We fill this future with cyborgs and robots but also true heroes who fight the war against AI. We fill it with the fear to lose our own humanity. This is what most Science Fiction characters have in common: they try to find the answer to what it is that makes us human. When a robot can think for itself, surely it is no longer a machine? Sometimes we fight together with our own creations, sometimes they turn against us. Sometimes hard-boiled women meet terrifying aliens and find out that evil is often deep routed on the inside. And sometimes we are simply looking for oil. The future is unknown, though not unfilmed.

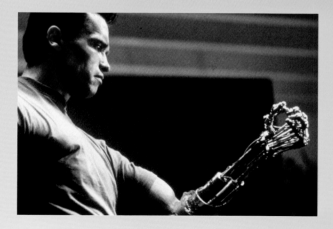
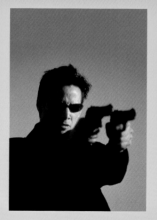
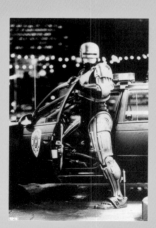

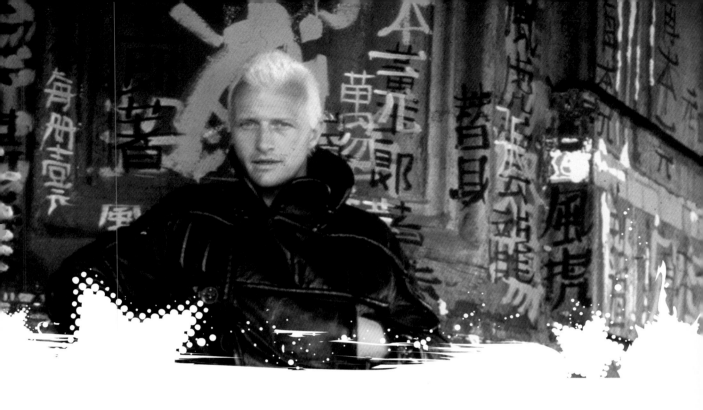

SCIENCE FICTION

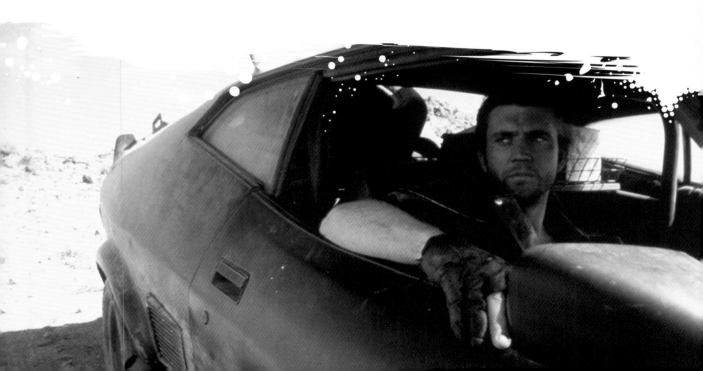

AGENT SMITH
HUGO WEAVING

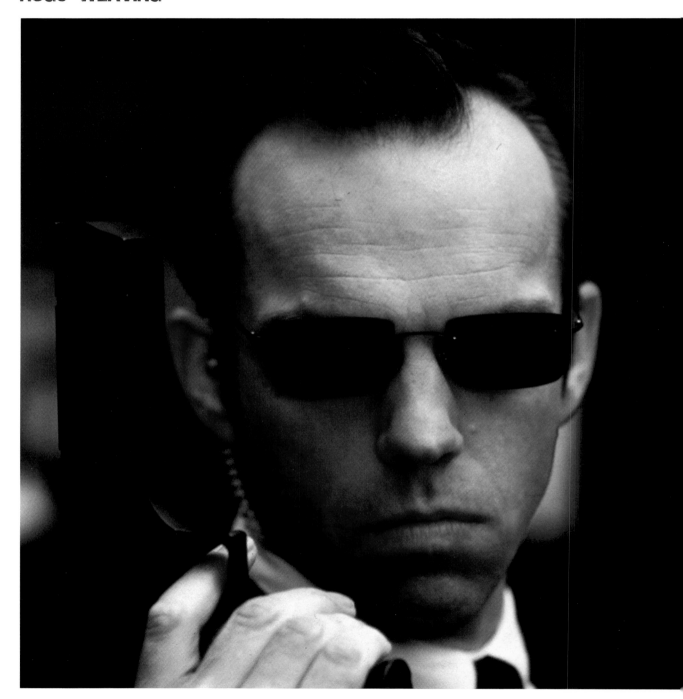

CHRIS PINE & ZACHARY QUINTO

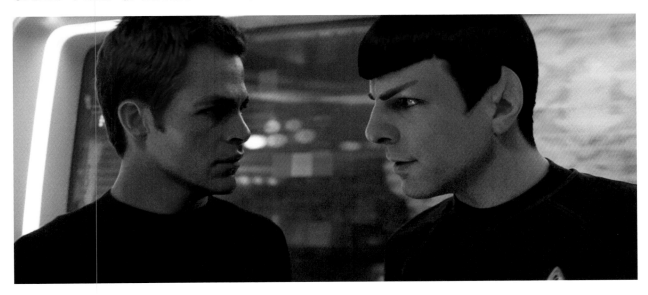

Star Trek : The Motion Picture (1979) – Robert Wise, *Star Trek II: The Wrath of Khan* (1982), *Star Trek VI: The Undiscovered Country* (1991) – Nicholas Meyer, *Star Trek III: The Search for Spock* (1984), *Star Trek IV: The Voyage Home* (1986) – Leonard Nimoy, *Star Trek V: The Final Frontier* (1989) – William Shatner, *Star Trek: Generations* (1994) – David Carnon
Star Trek (2009) – J.J. Abrams

Jim Kirk and Mr Spock. A *bromance in space*. One represents the true characteristics of the hero, the other takes on a distant and logical approach. Although they are each other's opposites, it is their relationship (as well as the other characters, special effects, *warp speed*, typical mythology and much more) that guaranteed the success of *Star Trek*, the series, the spin-offs and films, which all evolve around human relationships and intelligence. Kirk is the only student at the Starfleet Academy who defeated the no-win Kobayashi Maru Test and is Starfleet's youngest captain. Spock is Half-Vulcan (an extra-terrestrial species who live by reason) and struggles with his human feelings. The most recent film (for both die hard trekkies and new fans) expands on the 'love story' between Spock and Kirk and provides us with an insight into their lives when they were younger.

There is a never ending supply of memorable *Star Trek* moments and, without wanting to upset any fans, here is a random selection: the heroic self-sacrifice of Spock in *The Wrath of Khan*, the ludicrous scenes on present-day earth in *The Voyage Home* which show the comical and amusing side of both gentlemen (and Spock's white band fashion statement hiding his pointy eyebrows and ears). The 2009 film pictures a nearly romantic, *face to face* confrontation in which Kirk, following the advice of the Spock from the future (a cameo of Leonard Nimoy), must stimulate the young Spock's emotions and succeeds by insulting his dead mother. Finally, the well-known opening line which describes space as the final frontier, where no man has gone before, aside from the bold Starfleet crew!

DARTH VADER
DAVID PROWSE, JAMES EARL JONES (VOICE)

⚠

Star Wars : Episode IV – A New Hope (1977) – George Lucas, *Star Wars: Episode V – the Empire Strikes Back* (1980) – Irvin Kerschner, *Star Wars: Episode VI – Return of the Jedi* (1983) – Richard Marquand, *Star Wars: Episode III – Revenge of the Sith* (2005) – George Lucas

Additional actor: Hayden Christensen

Once, Darth Vader was Anakin Skywalker, a promising Jedi apprentice. He is tormented by the fear that his wife Padmé will die in childbirth and so is tempted by his later mentor Darth Sidious (or Emperor Palpatine) to join *the Dark Side* – with which powers he will be able to save Padmé. When he later hears of her death, he turns to the Dark Side for good. Although he is often considered to be the number one villain in film history, he also has a – well hidden – good side to him. This surfaces in the Star Wars prequels and his death scene. Good to know: James Earl Jones will later also lend his voice to Mufasa, the father of Simba from *The Lion King*.

Three moments from 'The Tragedy of Darth Vader' (as director Lucas calls his two trilogies) are both unforgettable and represent the transformation of the character. In *Episode III: Revenge of the Sith*, Anakin suffers burns after a fight with his old Master Obi-Wan Kenobi. In order to survive, his black armour with an oxygen mask is put on him. The villain is born. *Episode V: The Empire Strikes Back* contains one of the most well-known film quotes in history. Darth Vader reveals that he is Luke Skywalker's father. In the last episode of the original trilogy, *Return of the Jedi*, Vader saves his son from dying but loses his own life in the process. Before he dies, he reveals his face to Luke and redeems himself as Anakin who tells him that there was good left in him.

1 5 10

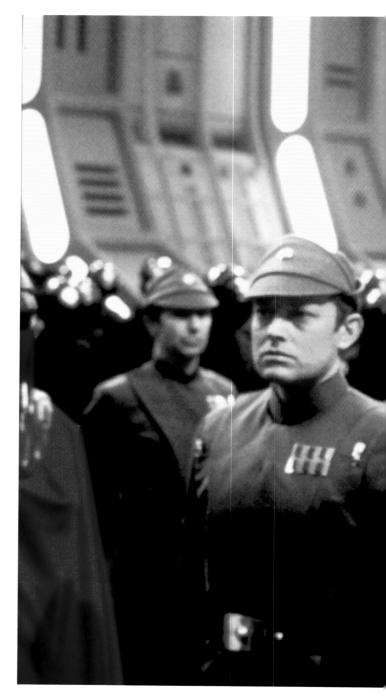

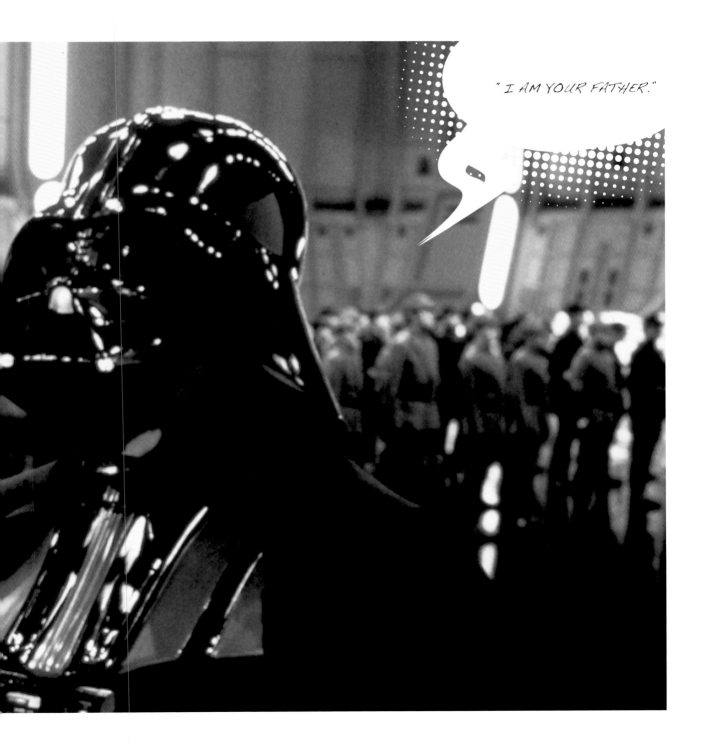

ELLEN RIPLEY
SIGOURNEY WEAVER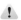

Alien (1979) – Ridley Scott, *Aliens* (1986) –
James Cameron, *Alien³* (1992) – David Fincher,
Alien : Resurrection (1997) – Jean-Pierre Jeunet

Although the four *Alien* films share the
same main character with the same name,
fighting the same monster and played by the
same actress, it is safe to say that there are four
unique heroes in four entirely different films.
Twice, Ellen Ripley is (as good as) the only
survivor of a confrontation with an extra-
terrestrial life form. Therefore, her aim in life
is to destroy the aliens for good. Not a
straightforward job, as the monsters are
examples of ultimate perfection and someone
is more interested in researching them for
their own benefit. Weaver turns Ripley into a
headstrong and sensual fighter who becomes
more daring as the films progress. She evolves
from a typical horror film character, via a
cunning hero with a distinct maternal instinct to
a martyr, to eventually return to a turbo version
of herself. Not many action films have a leading
lady but she could well be the strongest asset of
Alien.

The end of the first film is printed in
everyone's memory: Ripley who single-
handedly, wearing nothing more than a vest and
some extra small knickers, goes head to head
with the alien. Rumour has it that she was
meant to be naked in these scenes to better
portray her vulnerability. Luckily, 20th Century
Fox had other ideas as otherwise, we would not
have been able to enjoy the cutest builder's bum
in film history. Unforgettable is the confrontation
with the Queen in *Aliens* and her death in *Alien
3*: she throws herself into a furnace just as the
alien embryo begins to erupt from her chest. In
Alien: Resurrection it is Ripley's clone (number
8) who, in a scary scene, is confronted with the
results of previous reproduction attempts.

*" GET AWAY
FROM HER,
YOU BITCH!"*

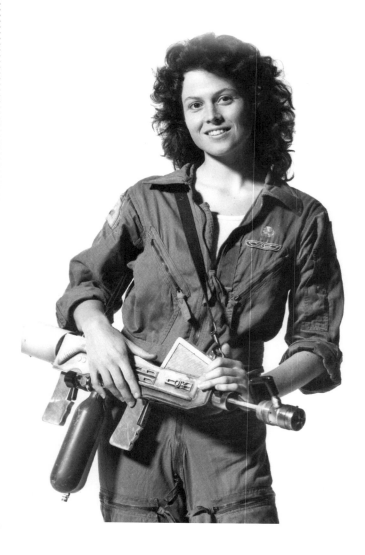

1 5 10

HAN SOLO
HARRISON FORD

📽 *Star Wars* (1977) – George Lucas, *Star Wars: Episode V – the Empire Strikes Back* (1980) – Irvin Kerschner, *Star Wars: Episode VI – Return of the Jedi* (1983) – Richard Marquand

🏷 Han Solo is a reckless smuggler and excellent pilot who navigates, together with his *Wookie* first mate, Chewbacca, *the Millennium Falcon* spaceship. He is more of an accidental hero who, after the promise of a large sum of money (with which he can pay back Jabba the Hutt) becomes involved in the Rebel Alliance against the Galactic Empire. Solo is known for his waistcoat and sarcastic wittiness, and is proud to have a reputation for being a nasty piece of work. He always looks angry, even if he is nice, which in *Episode V* leads to heated arguments with Princess Leia (Carrie Fisher) as both refuse to reveal their true feelings for each other. Yet Solo is charming and the film hero, so naturally he ends up with the girl (who is anything but a wee lass). The loner saves Luke Skywalker a few times from disaster and gradually learns the importance of solidarity.

📺 Two moments from a large selection in which Han Solo manages to keep his cool: In *Episode IV*, in the Mos Eisley Cantina, he becomes involved in a dispute with Greedo who wants to turn him over to Jabba the Hutt. Cool and collected, Solo sits at the table when he grabs his gun unnoticed and unexpectedly shoots Greedo. Fabulous! In *Episode V*, Darth Vader freezes Solo - once again, to hand him over to Jabba, but not before Leia has declared her love for him. Solo responds in his typical manner with "*I know*", though his eyes give away bravery and fondness. And they live happily ever after.

1 5 10

" I TAKE ORDERS FROM JUST ONE PERSON: ME."

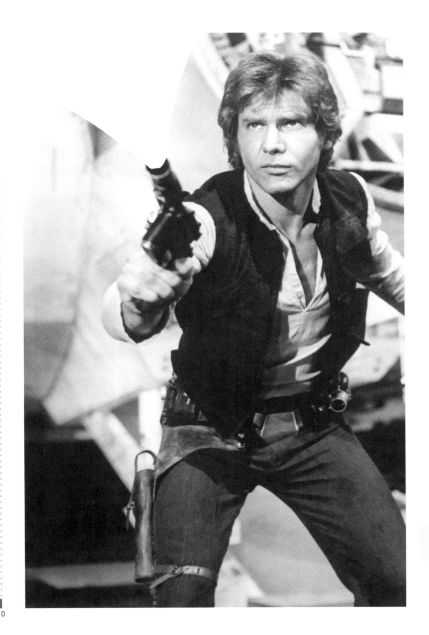

LUKE SKYWALKER
MARK HAMILL

*" I'M LUKE SKYWALKER.
I'M HERE TO RESCUE YOU!"*

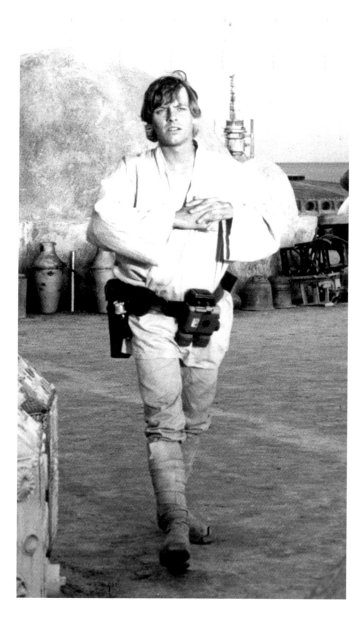

Star Wars (1977) – George Lucas, *Star Wars: Episode V – the Empire Strikes Back* (1980) – Irvin Kerschner, *Star Wars: Episode VI – Return of the Jedi* (1983) – Richard Marquand

When we meet Luke in *Episode IV*, he is a grumpy, boyish and careless young man who is naively ambitious. With the help of Obi-Wan Kenobi (Alec Guinness), who presents him with his father's lightsaber and inseparable droid R2-D2, he joins the Rebel Alliance against the Galactic Empire and learns about *The Force*. After the death of Obi-Wan, he is still guided by his spirit and starts his training as a Jedi Knight with Master Yoda. He finds out more about his father and sister (*Episode III* reveals that Luke and Leia's mother dies at childbirth after which they are separated and hidden from Darth Vader), and constantly has to resist temptation to explore the dark side. His flirting with evil finally comes to an end after a confrontation with Vader.

Two unforgettable Luke moments are the confrontations with Darth Vader. During the first and crucial encounter he loses his hand (which is later replaced by a prosthetic one) and is told by the evil *Lord* that he is not his father's murderer, but the man himself. Luke cries in disbelief and throws himself down a shaft. When they meet the next time in *Episode VI*, Vader threatens to turn Leia to the Dark Side. In his anger, and after he severs Vader's hand with his lightsaber, Luke realises he is on the verge of following Vader's path and refuses to kill him. When Darth Vader saves Luke from a painful death, he is mortally wounded. He asks his son to take off his mask when, for the very first and last time, Luke looks into the eyes of his real father, Anakin Skywalker.

1 5 10

SARAH CONNOR
LINDA HAMILTON

⚠️

🎬 *The Terminator* (1984), *Terminator 2: Judgment Day* (1991) – James Cameron

🏷️ The ruling robots from the future send a Terminator to the past to kill Sarah, mother of John Connor, leader of the resistance, to make sure he will never be born. John also sends back a sergeant, Kyle Reese, to protect her. During their brief time together, they fall in love, conceive John and kill the Terminator. From then on, Sarah carries on preparing her son for the resistance movement he must lead. She is declared mentally deranged and John is placed in a foster home. A second Terminator is sent but Sarah, with a wild look in her eyes and a muscular body in a see through white T-shirt, manages to escape helped by T-800 (Arnold Schwarzenegger) who was meant to kill her in the previous film. Together they try to put a stop to robots taking over.

⌐ The end of *The Terminator*, when Sarah crushes the cyborg in a hydraulic press, gives you an idea of the woman we will meet in part two. Nearly tougher than Arnie, and ruthless. It is only after she attempts to murder Dyson (the inventor of Skynet and indirectly responsible for the self-awareness of the robots) that she realises, partly thanks to her son, that she too has become a Terminator. Ultimately, she regains her humanity and we realise why John will go on to become the inspiration for a generation, based on his character and strict education. Another lasting memory earlier on in the film is when T-800 walks out of the lift and back into Sarah's life. She reacts as we all would do: hysterical, confused and scared to death. It takes a long time before he gains her trust.

1 5 10

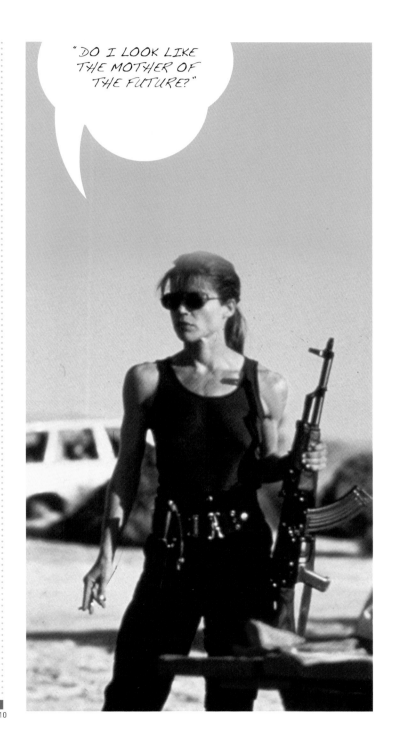

"DO I LOOK LIKE THE MOTHER OF THE FUTURE?"

THE TERMINATOR
ARNOLD SCHWARZENEGGER

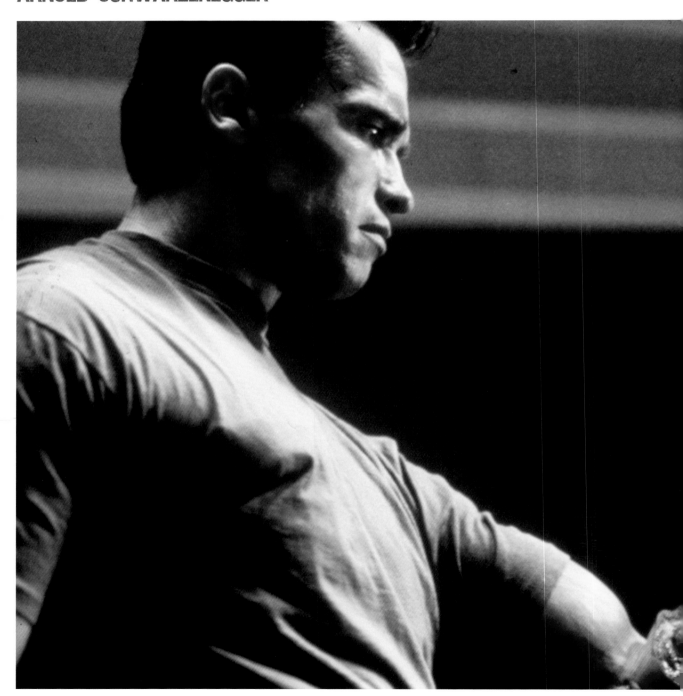

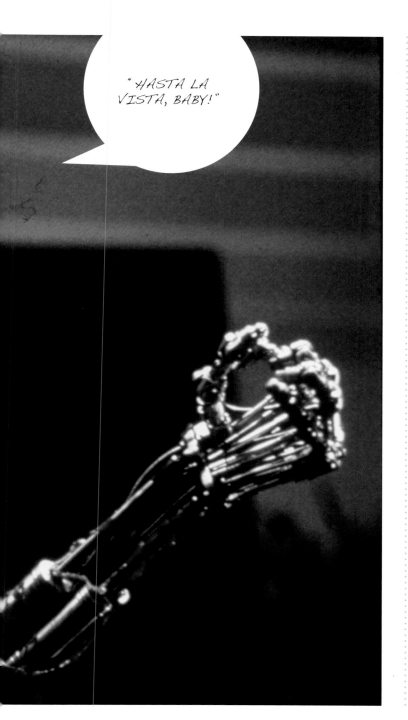

"HASTA LA VISTA, BABY!"

The Terminator (1984), Terminator 2: Judgment Day (1991) – James Cameron, Terminator 3: Rise of the Machines (2003) – Jonathan Mostow

The Terminator is a robot covered in flesh, who is sent to 1984 from the future to kill Sarah Connor for a 'retro-active abortion' – she must not give birth to her son as he will become the leader of a resistance movement against the robots. This apocalyptic classic is a sci-fi version of Annunciation Day from the New Testament, combined with a slasher film. Schwarzenegger, leathered up, and immune to pain and regret, is perfect as soulless killer. Although he is able to sweat and bleed, it is Arnie's Austrian accent and monotonous acting that remind us that he is still a cyborg. In the second (and third) film, a new version of him is sent to fight alongside John Connor. From villain to hero. He even promises to never kill and will only shoot to wound or scare someone.

Aside from the iconic I'll be Back moment (which does come as a surprise in the first Terminator film), it is the death of the cyborg in the first and second film that impresses most. In part one, Sarah Connor thinks she has defeated Arnold, yet he returns as a mechanical skeleton (his human flesh has been fully burnt). After a devil of a pursuit, Sarah manages to crush him and utters the famous words "You're terminated, sucker". In part two, the (good) Terminator asks Sarah to kill him by lowering him into melted steel which will destroy the last chip that contains the key to the robots. Whilst he is melting, he quickly gives her the thumbs up. That's our boy!

PSYCHOS

They live among us, we sit next to them on the bus, we
discuss the weather with them, even help them carry
their bags. And whilst they give us a friendly smile, they
fantasise about how to extract our finger nails...
From hysterical women to creepy men, from extravagant
renditions to smouldering evil and subdued characters.
Some were traumatised during their youth, other are
simply *pure evil*: psychopaths are a rewarding subject
for filmmakers and actors. And the audience has no
objection. Who does not enjoy an evening of creeping
flesh, a portion of *over-the-top* acting, a little Oedipus
complex here and a dose of war trauma there? Who
cares about the uneasy feeling, the nightmares and
paranoia!

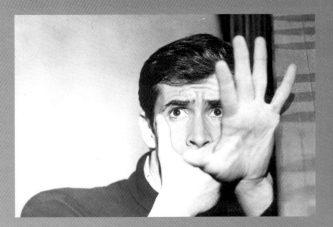
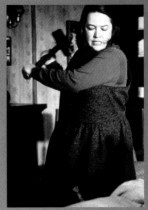
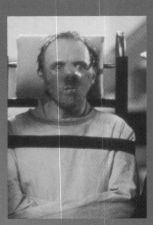

PSYCHOS

ALEX DELARGE
MALCOLM MCDOWELL

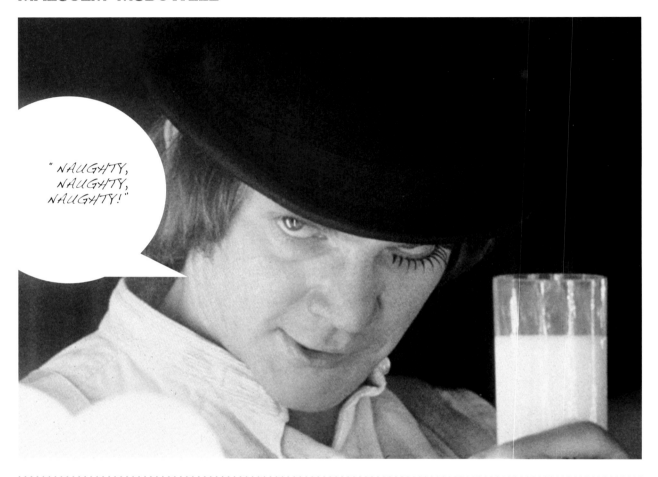

"NAUGHTY, NAUGHTY, NAUGHTY!"

A Clockwork Orange (1971) – Stanley Kubrick

Alex DeLarge is a disturbed young man in the novel by Anthony Burgess. He is the leader of the Droogs, a gang obsessed by destruction and rape but above all, excessive violence. They wear some sort of uniform and bowler hat, and speak Nadsat, a mixture of Russian and Cockney. Alex is very fond of Ludwig von Beethoven, whose music plays a crucial part in the film. His intelligence and self-awareness make his cruelty even more alarming.

The entire film is a compilation of classic film moments and singling one out is a shame for all the others, yet the scene that most people will remember is when Alex beats Mrs. Weathers to death with an enormous fake penis. For which he will eventually serve a sentence. His time in prison also brings some momentous scenes, if only because they are nearly more gruesome than the atrocities committed by the Droogs: Alex is forced to watch violent films whilst strapped in by a scary looking eye-opening piece of equipment.

1 5 10

ALEX FORREST
GLENN CLOSE ⓘ

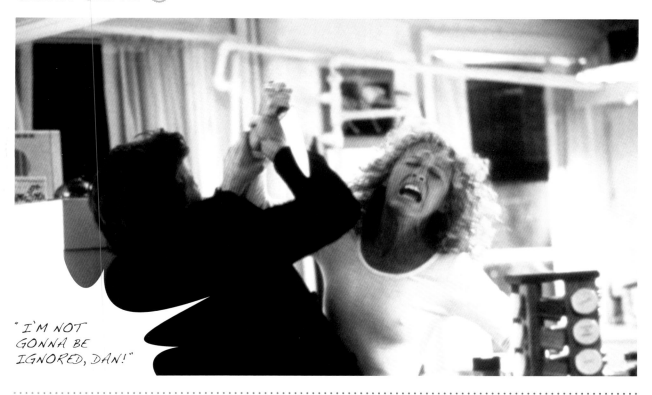

"I'M NOT GONNA BE IGNORED, DAN!"

🎬 *Fatal Attraction* (1987) – Adrien Lyne ⚠

🏷 Glenn Close has ended many affairs and saved numerous marriages thanks to her rendition of the psychotic lover Alex. After a weekend of passionate sex, which Dan (Michael Douglas) considers to be a simple fling, she begins to cling to him. She suffers from erotomania, the delusion that the other person is in love with her. She harasses Dan, phones him in the middle of the night, wrecks his car and visits his wife. Her attention seeking behaviour becomes more shocking – especially when she finds out she is pregnant. It emerges that Dan is a rather weak character. He is entirely dominated by Alex (from the moment he gives in to her seduction) and reacts indifferently to her pregnancy. Despite feminist criticism that a successful business woman is portrayed as psychotic, the film remains a classic which amuses women entertaining feelings of revenge and sends men a wake-up call!

The first 'oh-ow-moment' arrives when Alex cannot let Dan go and attempts suicide. We (and him) smell a rat. We still commiserate with her until she kills Dan's daughter's rabbit and puts it on the stove to boil. That is the end of our sympathy. Understandably, the plot was rewritten. Originally, Alex killed herself and Dan was arrested for murder. Although psychologically perhaps more realistic, the test audience did not respond well. The actual ending is slightly more horrific. Alex wants to eliminate Beth (Dan's wife), Dan seemingly drowns her in the bath and, remembered vividly by all, she emerges from the water once more holding a knife. The ultimate revenge takes place when Beth finally shoots her. In particular, Glenn Close had concerns about the alternative ending, although the scene became legendary.

1 5 10

ANNIE WILKES
KATHY BATES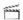

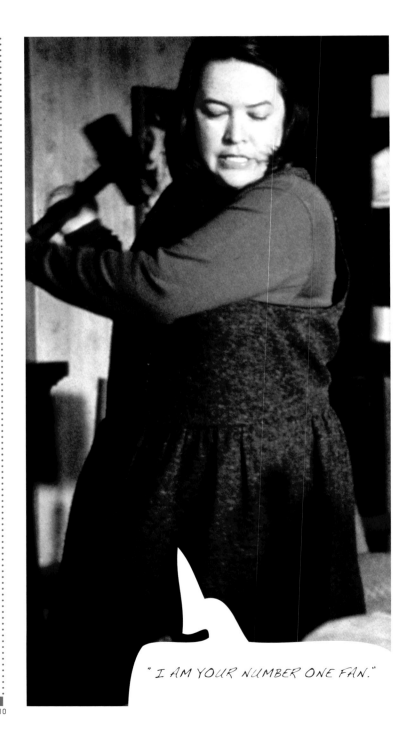

"I AM YOUR NUMBER ONE FAN."

🎬 *Misery* (1990) – Rob Reiner

🏷 The situation in which Paul Sheldon (James Caan), writer of the successful and romantic series starring Misery Chastain, ends up appeals to the audience in two deeply-routed fears: being helpless and fully at the mercy of a stranger, and tormented by a crazy stalker. The fan in question is Annie Wilkes, who saves Sheldon after an accident. With two broken legs and a dislocated shoulder, he is chained to his bed and nurse. It soon appears that Annie did not find him by accident and that she is anything but innocent. She flips when she finds out that the author has killed off Misery and forces him to write a sequel in which she is brought back to life. Annie makes your hair stand on end when she switches from chirpiness and concern to uncontrolled anger and contempt. Allergic to profane language, she subjects Sheldon seemingly unfazed to the most horrendous psychological and physical tortures.

▢ *Misery*, an adaptation of the novel by Stephen King offers great suspense: the audience knows that Misery is dead, Paul Sheldon knows it and soon will Annie. It is teeth-grindingly enervating waiting until the psychopath has read the end of the novel, and her anticipated rage does not disappoint. The way Annie is framed when angry, lit up and filmed from below, leaves a lasting impression. One of the most infamous scenes is when she breaks Sheldon's ankles with a sledgehammer. She remains calm and friendly, like she is nearly doing him a favour. Caan delivers an outstanding performance of Sheldon's passive fear, and the second in which we see his feet being chopped off, is one to make our stomachs churn.

1 5 10

ANTON CHIGURH
JAVIER BARDEM ⓘ

" WHAT BUSINESS IS IT OF YOURS WHERE I'M FROM... FRIENDO?"

🎬 *No Country for old men* (2007) – Ethan & Joel Coen

🏷️ The main villain in the novel by Cormac McCarthy and the film of the same name is Anton Chigurh, a hitman who is hired to retrieve a bag of money from a drug deal that went wrong. No sooner does he kill his client and hunt down the money for personal use. Though it is not money that seems to drive him. He is one big mystery, comparable to a horror character, armed with a pistol used to kill cattle. No one knows where he comes from or what he wants. His *looks* are also alien (particularly his much-talked-about haircut). He has a personal moral, that of heads or tails: his victims must toss a coin to determine their outcome but eventually no one will escape their fate. Chigurh, a frightening Javier Bardem, is a superb villain. The audience holds their breath when he appears, but through fear or pleasure?

📺 We soon discover what type of character he is when he strangles a police officer with his handcuffs. The details in this scene are phenomenal: they are both on the floor struggling but the only thing we hear is their groans and squeaking shoes on the lino. We are left with black marks on the floor as a result. Anton's look when he is attempting to kill the police officer is not necessarily cold but nearly confused, as if he is miles away. The shoot-out at the motel also stands out as Chigurh remains gruesomely evil, even on his white socks.

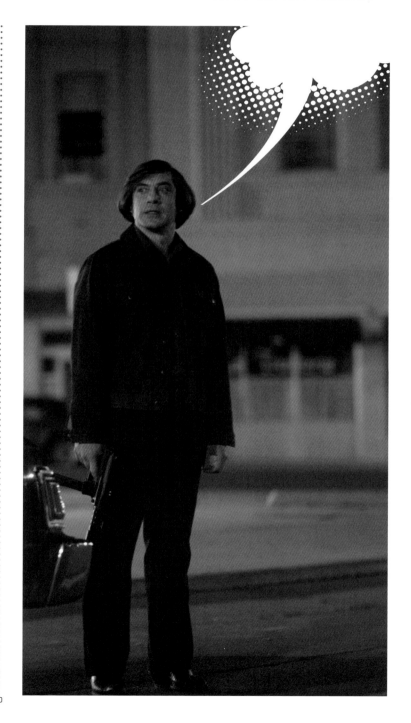

1 5 10

BILL 'THE BUTCHER' CUTTING
DANIEL DAY LEWIS ①

"THAT'S WHAT PRESERVES THE ORDER OF THINGS. FEAR."

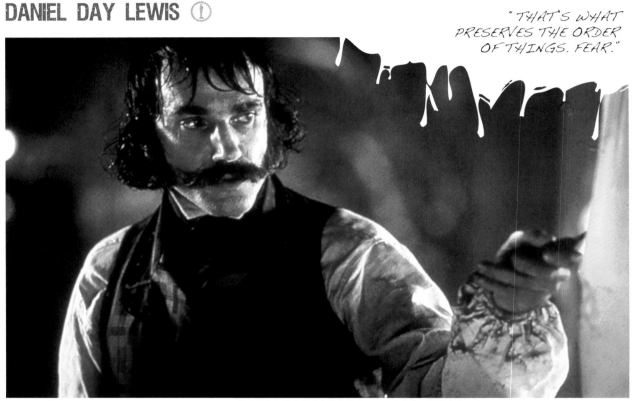

Gangs of New York (2002) - Martin Scorsese

Bill Cutting is loosely based on William Poole, gang leader and ally of corrupt politicians in the New York of 1850. He is the leader of the 'Natives', white Protestants and 'pure' Americans with an open hatred of immigrants. 'The Butcher' kills the leader of the Irish, Priest Vallon, and 16 years later his son Amsterdam (Leonardo DiCaprio) wants to exact revenge by firstly gaining Bill's confidence and then killing him on the anniversary of his self-invented holiday. The villain outshines the hero in this film as Scorsese directs Day-Lewis to portray a grotesque character. He may seem like a cartoon character with his top hat, three piece suit, big moustache and glass eye but his leering look is real – and he loves it. The combination of his strange accent, relentless philosophical sadism and even humour turn him into a constant threat. Practicing his talents as a knife fighter, he can explode after a dose of smooth talking to then horrifically kill his opponent.

Gangs of New York is marked by a bestial cruelty – butcher knives and razor blades take preference over guns. In one of the highlights of the film, Bill, the butcher, explains to Amsterdam – in a bizarre mood of affection – the different ways to kill a man with a knife, using a pig's carcass as an example. Later on, we are treated to a blood-curdling moment when Bill makes an outstanding appearance as knife thrower. We are probably not the only ones holding our breath when 'the Butcher' drives Amsterdam's girlfriend (Cameron Diaz) into a corner.

1 5 10

FRANK BOOTH
DENNIS HOPPER

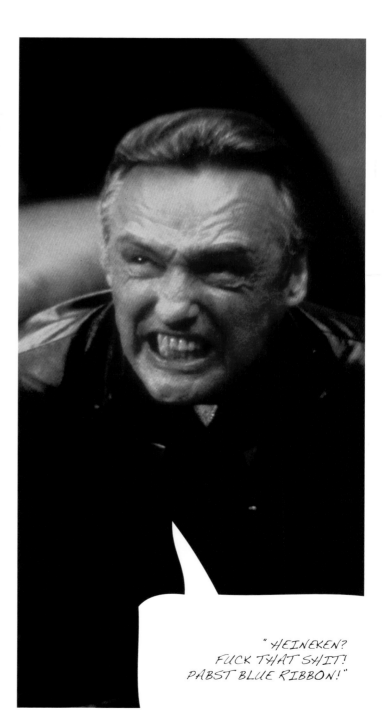

Blue Velvet (1986) - David Lynch

In this surrealistic neo-noir, Jeffrey Beaumont (Kyle MacLachlan) finds a human ear and becomes absorbed into a mystery that will reveal the underworld of his perfect and unsuspecting suburb. A mystery in which torch singer Dorothy Vallens (Isabella Rossellini) consents to sexual abuse from the obscene and sadistic Frank Booth as he holds her husband and child hostage. The legendary character of the perverse and oxygen inhaling psychopath brought Dennis Hopper back to the big screen. *Blue Velvet*, an instant cult classic, reveals what is hidden in both America and human beings. That which is hidden in Booth, should have stayed there. His drug abuse and abnormal sexual fantasies transform him, mainly thanks to Hopper's spine-chilling performance, into the scariest Lynch villain. Which means: sca-ry. The world is slightly more beautiful when he is shot dead.

The famous opening sequence evokes the atmosphere of an American suburb and all its scandals and sets the scene for a stylish and theatrical film. Later, like in a Hitchcock scene, Beaumont, hidden in a cupboard in Dorothy's apartment, witnesses Booth raping her. One of the things that contribute to the overall mood in the film is the song *Blue Velvet* by Bobby Vinton, sung by Isabella Rossellini whilst Booth caresses a blue piece of velvet, like a child cuddling his favourite teddy bear. That Booth is a crooner fan is also clear when he, with a face full of lipstick, attacks Beaumont, with, in the background a prostitute dancing on the roof of his car, whilst lip-syncing *In Dreams* by Roy Orbison.

"HEINEKEN? FUCK THAT SHIT! PABST BLUE RIBBON!"

1 5 10

HANNIBAL LECTER
ANTHONY HOPKINS ①

Manhunter (1986) – Michael Mann
The Silence of the Lambs (1991) – Jonathan Demme,
Hannibal (2001) – Ridley Scott, *Red Dragon* (2002) – Brett Ratner
Hannibal Rising (2007) – Peter Webber

Additional actors: Brian Cox and Gaspard Ulliel

Thomas Harris wrote four books about Dr. Lecter who became world famous in the films starring Anthony Hopkins. After his Latvian parents are killed by a Russian fighter plane and hungry soldiers cannibalise his sister (offering him some soup), he escapes and ends up in America. He is an outstanding psychiatrist but kills his patients and eats their liver. When he is arrested, he helps to catch other serial killers such as Francis Dolarhyde ('Red Dragon') and Jame Gumb ('Buffalo Bill') from his prison cell. *'Hannibal the Cannibal'* is extremely intelligent and knows exactly how to win people over. He is endearing and honest, with a horrifying downside to him. It is his ambiguous relationship with detective Clarice Starling that gives him his human character. He makes a 180 degree turn going from killer to antihero, punishing 'bad' people.

Four books, five films and a fine selection of legendary quotations - think back to the end of *The Silence of the Lambs* for example... We all remember the relationship between Clarice and Hannibal, and especially their conversations with only a glass wall in between. There are also a number of atrocities we can recall: his escape from the cage in *Silence* and him feeding sautéed brain, fresh from the cut open skull, to its owner in *Hannibal*. It is then that we realise we are dealing with Dr. Lecter the psychopath rather than the friendly and well-spoken gentleman we saw earlier.

1 5 10

ROBERT DE NIRO ①

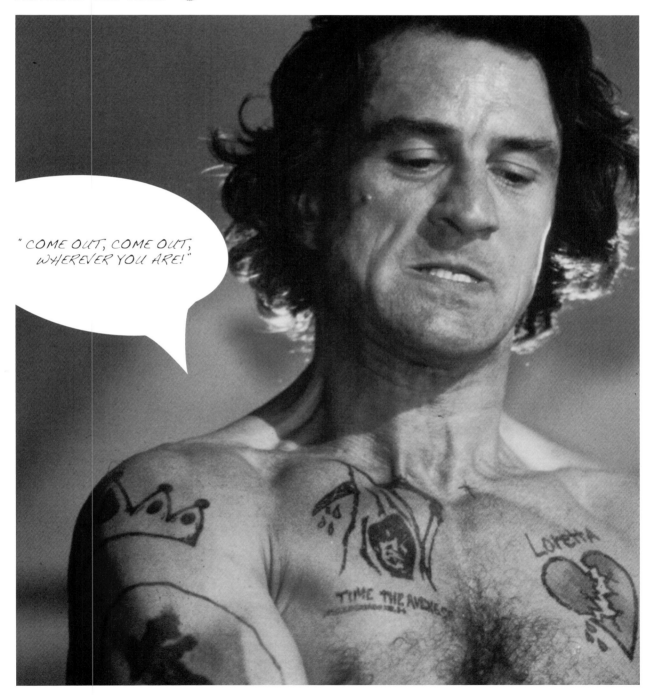

MICKEY & MALLORY KNOX
WOODY HARRELSON & JULIETTE LEWIS

*" IT'S JUST MURDER.
ALL GOD'S CREATURES DO IT."*

Natural Born Killers (1994) – Oliver Stone

Oliver Stone, not a fan of understatements, ventilates satirical criticism on the modern media and its exploitation of violence in a frantic style (a mixture of black and white documentary shots, CCTV footage, animation, filters, colour schemes, special effects, parodies of television programmes, parts of TV adverts and a cacophony on the soundtrack). Both the style and characters are violent which gives you the impression of zapping around under the influence of hallucinatory drugs. Much of the story of Mickey and Mallory Knox, the modern day version of Bonnie and Clyde, is told via parodies of television shows which creates a distance. The psychotic newlyweds claim 52 victims but ensure that they have witnesses who live to tell the tale. They jump at the chance to acquire some fame for their bloodbaths. With the help of journalist Wayne Gale and their clever manipulation of the media, they soon become national heroes.

We first meet Mickey and Mallory in the setting of a sitcom, including a laughing audience track – laughing hardest when Mallory's father makes incestuous remarks. Mickey as a blood-covered butcher's assistant is a more plastic version of the prince on a white horse, and the murder of Mal's parents a nearly heroic deed – backed up by loud applause. The second part of the film has more of a storyboard and is mainly focused on Wayne Gale's interview (Robert Downey Jr.) with Mickey. We see and hear the killer with a seductive, yet threatening twinkle in his eyes and bald head discuss his philosophy in life and lack of remorse. He hypnotises the audience and interviewer and incites a riot amongst his fellow inmates. Gale cannot believe his luck whilst Tommy Lee Jones as the prison director hits the roof.

1 5 10

NORMAN BATES
ANTHONY PERKINS

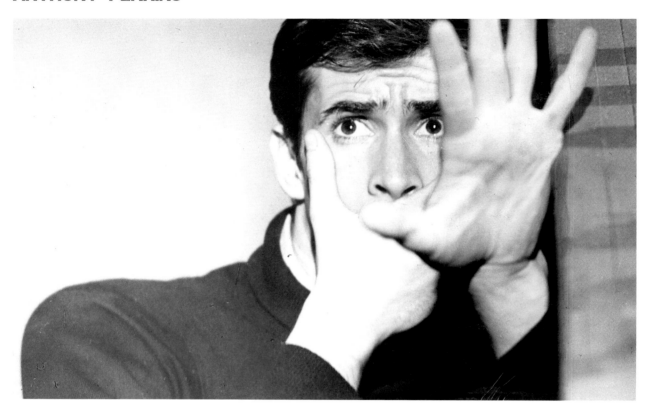

🎬 *Psycho* (1960) – Alfred Hitchcock, *Psycho 2* (1983) – Richard Franklin, *Psycho 3* (1986) – Anthony Perkins *Psycho* (1998) – Gus Van Sant

🏷 Norman Bates was created by author Robert Bloch and is based on Ed Gein, an American killer and grave robber. The death of his mother traumatises Gein: he designed a 'woman suit' so he could pretend to be a female. In *Psycho*, a jealous Norman kills his mother and her lover. He keeps her body in the cellar. At the same time, he develops a split personality: he pretends that is mother is still alive, and he takes on the role himself. Norman runs a motel and lives in that well-known creepy house. He stuffs birds, and although friendly at first sight, he turns out to be dangerous and sly – to protect his 'mother'. Looking back, he can be somewhat forgiven. He is traumatised and mentally ill. But scary nevertheless.

It is impossible to forget the shower scene when thinking of *Psycho*. What makes this scene so special is the iconic value (Janet Leigh dies in the first part of the film) and the fact that absolutely nothing is revealed. Although it is one of the most scary scenes in film history, there is no violence shown: no knife stabbing and hardly a killer in sight, and all this thanks to Hitchcock's superb editing skills. We would also like to mention the what-was-the-purpose-of-that shot for shot remake by Gus Van Sant starring Vince Vaughn. A wasted effort: Alfred is the one and only Hitchcock and Anthony Perkins the only Norman Bates.

1 5 10

HEROIC HEROES

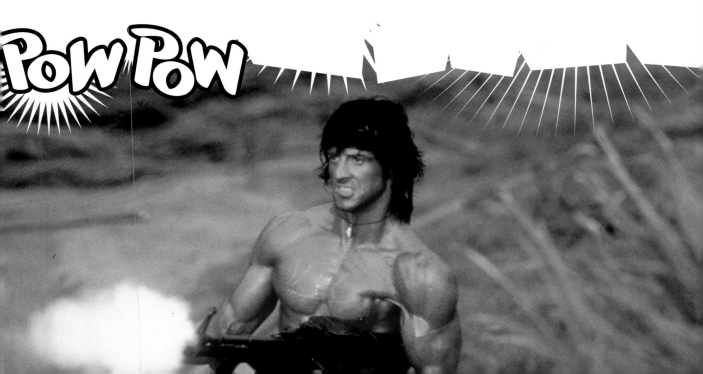

POW POW

ETHAN EDWARDS
JOHN WAYNE

 The Searchers (1956) - John Ford

In 1868, ex-soldier Ethan Edwards returns to the Texan branch of his brother. The reason why he hasn't immediately returned after the civil war is clear from a few stolen glances: he is in love with his sister-in-law Martha. During a Comanche raid on the ranch, she is raped and brutally murdered. Ethan's brother and his son also die. The two daughters, Debbie and Lucy, are kidnapped. Ethan and Martin – the adopted son of the Edwards, go out to find the girls, a hunt which will eventually last five years. Although Ethan is driven by racism and wants to kill Debbie as she has been besmirched by the Comanches (she has become his archenemy's wife), we still like him. And that is the beauty of this fantastic Western.

The film starts with Martha opening a door. We see a bleak landscape with Ethan approaching in the distance (which provides a nice contrast between the dark inside and the Technicolor outside). The famous final scene is the opposite: Ethan takes Debbie back to the ranch, leads her inside and wonders off onto the prairie. Alone. Upon which the door shuts. Between start and finish, there are naturally a number of classic John Wayne moments in which he slowly grows on you.

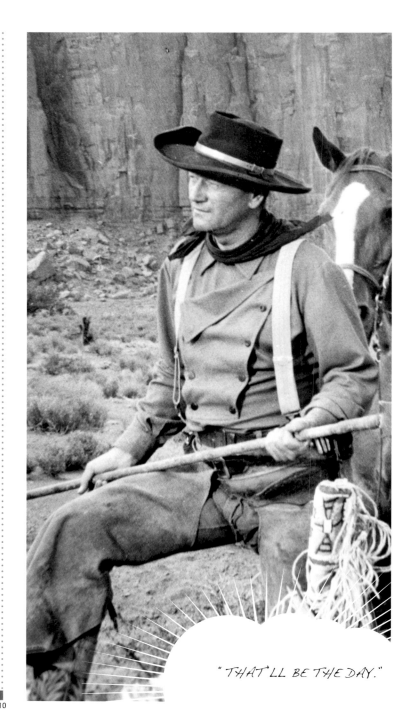

"THAT'LL BE THE DAY."

1 5 10

ETHAN HUNT
TOM CRUISE

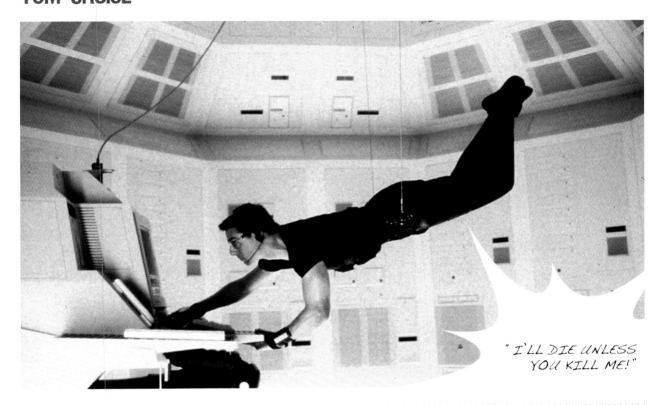

" I`LL DIE UNLESS YOU KILL ME!"

Mission: Impossible (1996) – Brian De Palma, *Mission: Impossible II* (2000) – John Woo, *Mission: Impossible III* (2006) – J.J. Abrams, *Mission: Impossible IV* (2011) – Brad Bird

The film character (based on the popular television series) Ethan Hunt is a secret agent for the IMF or 'Impossible Mission Force', a (fictional) independent espionage agency employed by the US government. All his actions are typical of this type of film, and of a Tom Cruise character: although he is rather boring as a person, he is beyond reproach, fit, brazen and fearless, and driven to complete his mission or clear his name – as is his task in the first film after being framed. As the sole survivor of a shoot-out during a mission, he becomes the prime suspect. Similar to James Bond or Jason Bourne, he effortlessly travels the world and constantly seems to be wound up like a spring. He constantly has that untameable look in his eyes.

The second film in the franchise should have self-destructed in five seconds, so no further comments there. The first film on the other hand, presents a great moment: Ethan Hunt has broken into the Pentagon to copy a disk. He is hanging from a cable above the computer. Under no circumstances must he touch the ground or break out in a sweat as his raised body temperature would set off an alarm which would fail the mission. The third film contains a couple of brilliant scenes where Philip Seymour Hoffman, as super villain, blackmails Ethan – with rarely seen before, immense hatred in Tom Cruise's eyes. Finally, we must mention the real-life face masks used in the films: 'I'm not who you think I am! Surprise!' Unbelievable, yet always a winner...

1 5 10

GENERAL MAXIMUS DECIMUS MERIDIUS
RUSSELL CROWE ①

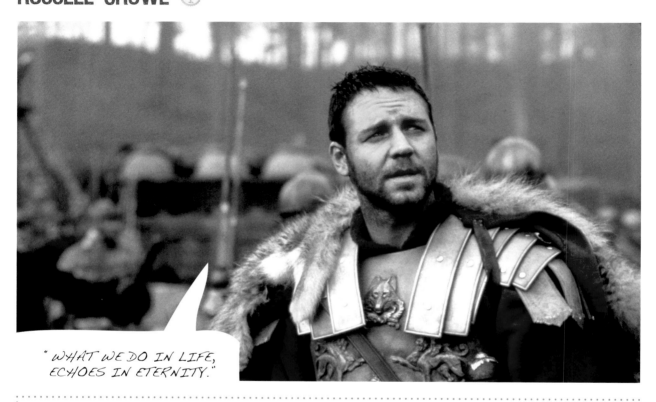

" WHAT WE DO IN LIFE, ECHOES IN ETERNITY."

🎬 *Gladiator* (2000) – Ridley Scott

🏷 General Maximus Decimus Meridius is an honourable general, loyal to the aging emperor Marcus Aurelius. He intends to hand over his power to Maximus which provokes anger from his jealous son Commodus (Joaquin Phoenix). Maximus' son and wife are killed, his house destroyed and after some aimless wandering, he is sold into slavery, ending up in the gladiator business. His vendetta is about to commence. The love for his family and refrained anger cause him to seek vengeance against Commodus, although he is now a slave. Few films exist with a subdued and even depressed protagonist that still draw you in like *Gladiator* does. The answer is Russell Crowe, the perfect antihero who smoothly and quick-tempered whizzes by, with or without sword. Commonly known as the 'Spaniard', he becomes the public's favourite in the Colosseum and patiently suffers all humiliation. He knows that his time will come. In this life or the next.

🎬 Director Ridley Scott is a pro at staging action and fight scenes, leaving no shortage in this sandal film – for example, the battle in the beginning and the Spaniard's fight with a streak of tigers and a man twice his size. However, the most special moments are those when the noble and fiery Maximus challenges his opponent Commodus. Even when he wins the sympathy of the audience after a fight, he is made to reveal his true identity to the new emperor – after he introduced himself as '*I am gladiator*'. He is a man of few words but when he does speak, it is poignant and he even gains a little triumph. The emperor is shocked to see Maximus still alive, yet he is unable to kill him without losing his popularity with the public.

1 5 10

INDIANA JONES
HARRISON FORD

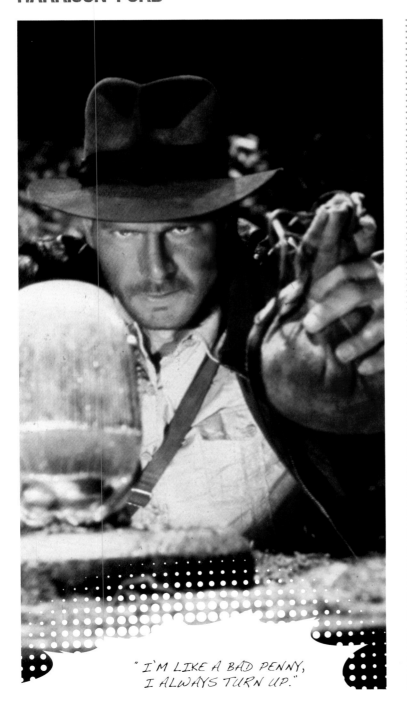

" I'M LIKE A BAD PENNY,
I ALWAYS TURN UP."

Raiders of the Lost Ark (1981), *Indiana Jones and the Temple of Doom* (1984), *Indiana Jones and the Last Crusade* (1989), *Indiana Jones and the Kingdom of the Crystal Skull* (2008) – Steven Spielberg

Henry Walton Jones Jr., PhD (or 'Indiana' after the dog of creator George Lucas) is an archaeologist, adventurer and true hero. His biggest charm is that he laughs at danger, his enemies and above all, himself. Based on comic hero Tintin and the adventure film serials, he has a lot going for himself: sense of humour, intelligence (he speaks 27 languages!), modesty and notable look (his hat, whip and leather jacket). Action scenes are full of excitement and he always seems to be enjoying himself. His various opponents also add to the fun: from poisonous snakes and Nazis to Russian spies. As with every film hero of importance, fans get excited by hearing only the theme tune. In his case, *The Raiders March*. Even the familiar font of the title has a similar effect.

The trouble Indiana Jones regularly finds himself in is legendary, as are his many escapes. Everything collapses behind him, he is attacked by animals, exposed to booby traps and (as in the famous opening scene of *Raiders of the Lost Ark* in a Peruvian temple) chased by a rolling rock. Also typical are the unexpected turns, in which friends suddenly appear to be enemies! The fourth film (with a 65 year old hero) opens with Indiana's hat falling onto the ground, after which we finally see him again. Both Indiana and Harrison Ford quickly admit that things will not be as easy as 20 years ago...

1 5 10

JAMES BOND
SEAN CONNERY

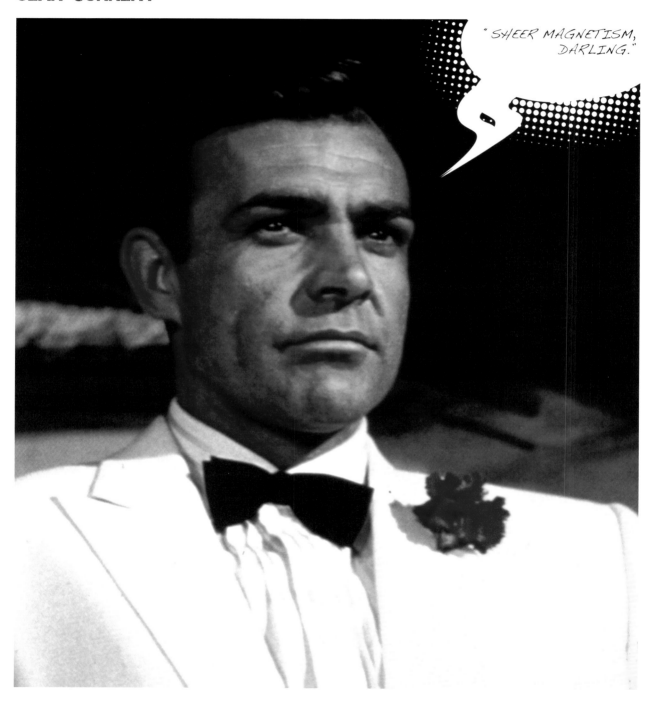

ROGER MOORE

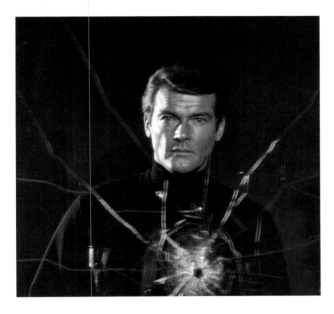

TIMOTHY DALTON

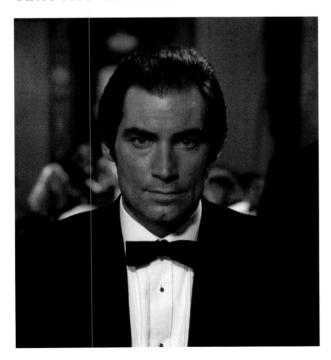

Dr. No (1963), *From Russia with Love* (1963), *Thunderball* (1965) - Terence Young
Goldfinger (1964), *Diamonds are Forever* (1971), *Live and Let Die* (1973), *The Man with The Golden Gun* (1974) - Guy Hamilton
You Only Live Twice (1967), *The Spy who Loved me* (1977), *Moonraker* (1979) - Lewis Gilbert
On Her Majesty's Secret Service (1969) - Peter Hunt
For your Eyes Only (1981), *Octopussy* (1983), *A View to Kill* (1985) - John Glen
GoldenEye (1995), *Casino Royale* (2006) - Martin Campbell
Tomorrow Never Dies (1997) - Roger Spottiswoode
The World is not enough (1999) - Michael Apted
Die Another Day (2002) - Lee Tamahori
Quantum of Solace (2008) - Marc Forster

Every generation has its own 007. And although Sean Connery, as the very first Bond, is most popular (author Ian Flemming even gave him a Scottish background in honour of the actor), all other actors have contributed to this iconic character. The British spy with a 'license to kill' gained humour with Roger Moore, became more serious with Timothy Dalton, acquired extra charm with Pierce Brosnan and grew more rough with Daniel Craig. The dose of gadgets (and their '*master*' Q) evolve from changing number plates to invisible cars. One thing remains unchanged: James Bond's nerve. We hardly know any of his personal details but that is not important. We know he is a loner with an enormously expensive dress sense, and a passion for great locations, cars and girls. Often sexist and politically incorrect, we cannot but love the Bond films.

Women with names referring to intimate body parts or bed skills are Bond's main weakness. He winds them all around his little finger, although often this nearly ends in disaster. Even when they try to kill him, he will intentionally frolic around with them. All in the name of his country, of course. Using numerous one-liners, at the most exotic locations, whilst escaping tricky situations in the most spectacular ways, preferably aided by a gadget and rescuing a sexy lady from near death in the process, whilst sipping a shaken Martini, is the image of a Bond that all men long to have.

JAMES BOND
GEORGE LAZENBY

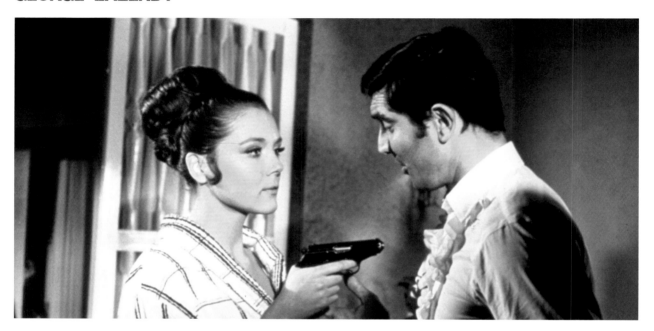

PIERCE BROSNAN

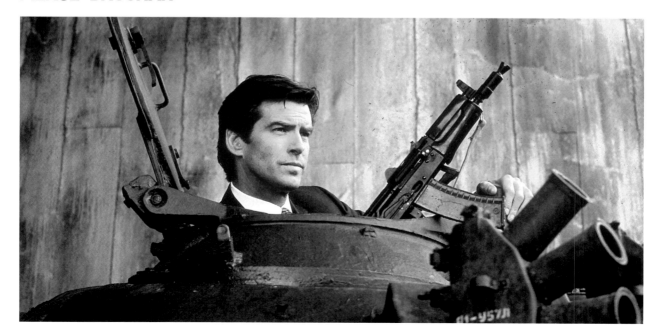

DANIEL CRAIG

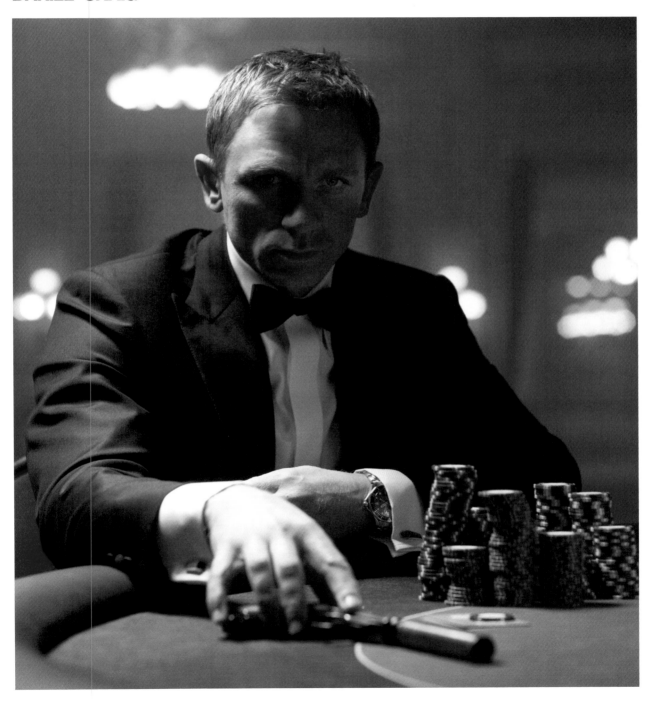

JASON BOURNE
MATT DAMON

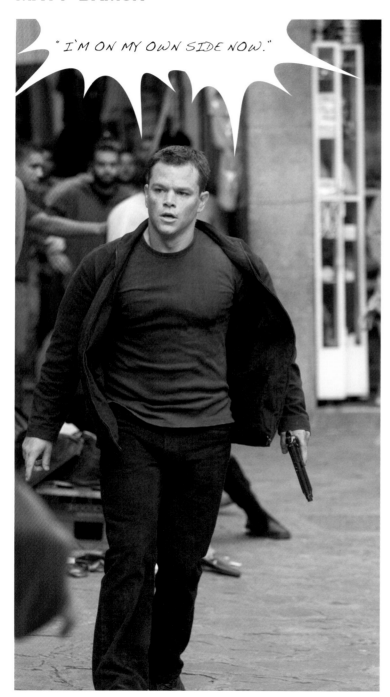

" I`M ON MY OWN SIDE NOW."

⚠

🎬 *The Bourne Identity* (2002) –
Doug Liman, *The Bourne Supremacy* (2004),
The Bourne Ultimatum (2007) –
Paul Greengrass

🏷 Jason Bourne is based on the character
from the books by Robert Ludlum. In
comparison to the 1988 series, the recent
films do not literally follow the books. Bourne
is picked up from sea with two gunshot
wounds to his back, an account number in
his hip and suffering from amnesia. He
discovers that he speaks several languages,
is a skilled fighting machine and has an
incredible perceptive mind. Trying to find out
his own identity, he discovers that he used
to be an assassin for the 'Special Activities'
department of the CIA. He tries to distance
himself from them but keeps on being
chased by his previous employers. The three
films show his quest for his mysterious past
and the CIA's round-up. He becomes a
James Bond on the loose, without the fancy
gadgets.

🎞 *The Bourne Identity* portrays Jason as
superhero. He discovers, nilly-willy, that he
has special powers. The scenes in which he
defends himself on automatic pilot are
fascinating and come as a surprise for both
the character and us. The best scenes wait
until last. The third sequel shows Bourne
more adapted to the action and in the mood
for some entertaining dialogues. The film
has an open ending which leaves room for
perhaps one more. Bourne is shot and falls
from a block a flats into the water, however,
his body is never found...

1 5 10

"YO ADRIAN!
I DID IT!"

Rocky (1976), Rocky V (1990) – John
G. Avildsen, Rocky II (1979), Rocky III
(1982), Rocky IV (1985), Rocky Balboa
(2006) – Sylvester Stallone

Rocky, written by Stallone himself,
won an Oscar for best film in 1976. The
hero of the day, Italian Stallion and
left-handed boxer, won many hearts all
over the world. Rocky is gullible and
crude but behind this facade is a
heart-warming man: although he is
somewhat disappointed in life, he
remains naive, optimistic and kind. We
are genuinely touched by his muttering,
his fighting spirit and (surprising) love
for the shy Adrian (Talia Shire). Rocky
will never give up, a trait that
characterises both the hero and its
actor, who had to fight hard to see his
screenplay turned into a film. Rocky
turned out to be a box office success –
with, time after time, a similar scenario.
Against all expectations, the latest film
from 2006 ended up on top as it was 30
years ago.

The realistic boxing matches
against unforgettable opponents such as
Carl Weathers, Mr T and Dolph Lundgren
are impressive but there are many more
Rocky filled moments. Not to mention
the famous scene on the stairs in the
first film, accompanied by the theme
song by Bill Conti, when a young Rocky
jumps in the air with joy which makes us
all want to join in. The interaction with
Adrian and their awakening love is also
nice to watch. Rocky Balboa continues
the franchise of the first two (and best)
films and concludes the story of this
incredible and popular hero.

1 5 10

SHANE
ALAN LADD

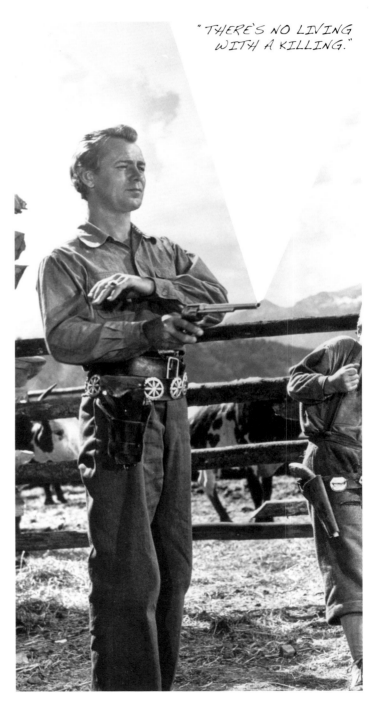

"THERE'S NO LIVING WITH A KILLING."

📋 *Shane* (1953) – George Stevens

🏷 *Shane*, based on the novel of the same name by Jack Schaefer from 1949, is situated near the colonisation border in Wyoming. A mysterious man intervenes when homesteader Joe Starret (Van Heflin) and a cattle baron clash. Little is revealed about the unknown mediator. He doesn't want to be reminded of his past as a gunslinger and is drawn to the hominess that he finds on Joe's farm. He always looks a little feminine, especially in comparison with the other – rough – men, and to start with, he gives the impression of being a weakling which is definitely not the case. Shane feels attracted to Joe's wife Marian (Jean Arthur), a feeling which is mutual. Yet, out of respect and love for her husband, both ignore their feelings. Shane's young son Joey (Brandon De Wilde) on the other hand, finds it difficult to ignore his feelings of admiration for this new father figure.

🎬 Heart-warming is that first feeling when Shane and Joe create a bond. It is touching to see a stranger helping out Joe to chop down a tree trunk which had been an eyesore for years. It is though, mainly the final confrontation that we will not forget any time soon. Wilson (Jack Palance), an assassin ahead of his time, challenges one of the homesteaders to a deadly duel. Joe feels morally obliged to kill Wilson and the person who gave the order but is stopped by Shane who finishes off the job but not without getting wounded. All fights, and mainly this last one, are powerful and full of tension, particularly when you see innocent and naive Joey fascinated by the excitement. Shane bids the little boy farewell, gets onto his horse and rides off - perhaps to die in peace, perhaps to find new adventures as a *poor lonesome cowboy* - whilst Joey begs him with a world-famous quotation...

1 5 10

SPARTACUS
KIRK DOUGLAS

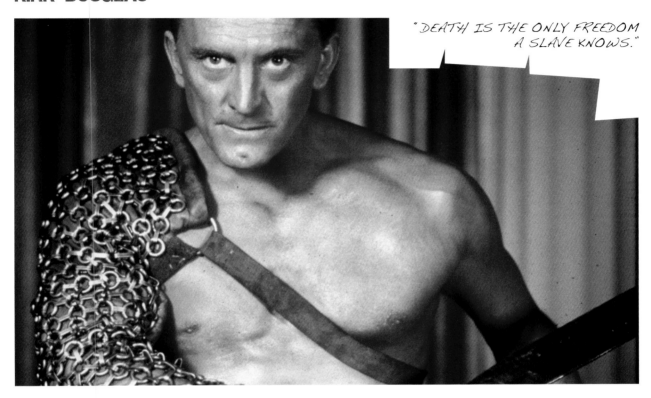

"DEATH IS THE ONLY FREEDOM A SLAVE KNOWS."

Spartacus (1960) – Stanley Kubrick

As he was turned down for the role, Kirk Douglas wanted to outstrip *Ben-Hur* with this adaptation of a novel by Howard Fast, based on a true story. Spartacus is picked up from the street, where he is slaving over the upkeep of roads, in order to become a gladiator. When another fighter refuses to kill him, but attacks the Roman audience instead, Spartacus causes a revolt. He is hindered by the other flamboyant characters played by Laurence Olivier (in a bisexual role), Charles Laughton and Peter Ustinov. His tanned skin, manicured hairstyle and dimple on his chin transform Kirk Douglas into an old-fashioned hero prototype: silent and sensitive but strong. He even becomes a bit of a Messiah when his death turns him into a martyr. The film feels modern due to the political theme, extraordinary ending and a hint of homosexuality, though it is still the perfect example of a Hollywood super production.

There are many classic and often parodied scenes in this sandal film, including the forced sword fight between Spartacus and Antoninus (Tony Curtis) and the moving '*I'm Spartacus*' scene. In the latter, rebellious slaves are promised that they will live if they give up Spartacus. They refuse and stand up, one by one, to say that they are Spartacus. The end of the film is not only special because not many people will manage to keep their tissue dry but also due to the unconventional and provocative character – the hero is not rewarded. After nearly nailing the system, the slave and his mates are nailed to the cross instead after suffering defeat. His wife Varinia (Jean Simmons) shows the dying Spartacus their son, who was born free, and begs her husband to die quickly.

1 5 10

TARZAN
JOHNNY WEISSMULLER

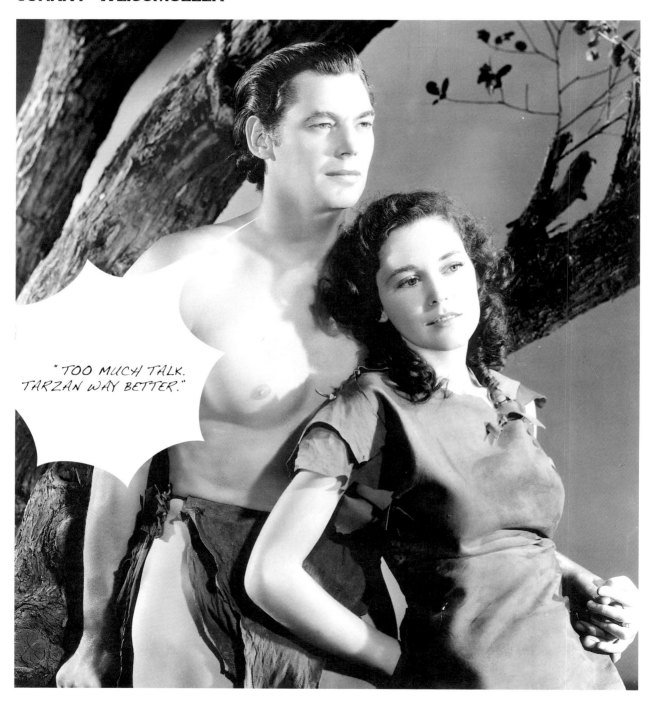

MILES O'KEEFFE

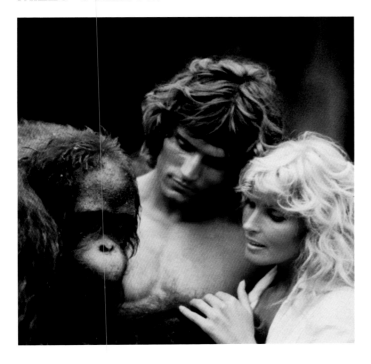

CHRISTOPHER LAMBERT

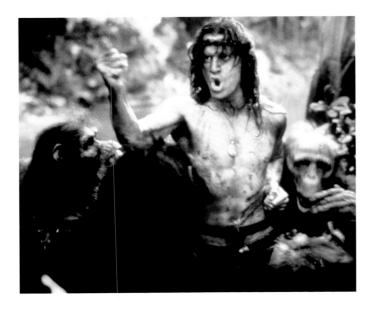

🎬 *Tarzan of the apes* (1918) – Scott Sidney
Tarzan the Ape Man (1932) – W.S. Van Dyke
The New Adventures of Tarzan (1935) – Edward A. Kull
Tarzan's Magic Fountain (1949) – Lee Sholem
Tarzan's Hidden Jungle (1955) – Harold D. Schuster
Tarzan, the Ape Man (1981) – John Derek
Greystoke: The Legend of Tarzan, Lord of the Apes (1984) – Hugh Hudson
Tarzan and the Lost City (1998) – Carl Schenkel
Tarzan (1999) – Chris Buck, Kevin Lima

Additional actors: amongst others Elmo Lincoln , Bruce Bennett, Lex Barker, Gordon Scott, Casper Van Dien and Tony Goldwyn

🏷 Tarzan, one of the characters that has been around longest in film history, appears for the first time in 1912, created by Edgar Rice Burroughs. He is the son of shipwrecked Lord and Lady Greystoke and is later adopted by his ape mother Kala. He even becomes king of the apes when he kills the alpha male in a fight. Sadly, he will never be one of them, as he will also never be part of the human race. There are numerous versions of this story but one character who will always make an appearance is Jane. Sometimes she stays with Tarzan and Cheetah in the jungle, other times she takes him back to England with her. There are versions where Tarzan is simply a sex object, the uneducated, yet tightly muscled wild man who seduces the female. In a more romantic version, he easily adapts to modern everyday life.

🎞 The most famous Tarzan is Olympic swimming champion Johnny Weissmuller who, between 1932 and 1948, made twelve films about the noble muscleman. His yell (you know: Aaaaheeaaheeaaa) was later used by other actors. Aside from Johnny, it is tricky to choose another Tarzan. However, some silent versions are fun, as are the terrible version with sexy Bo Derek, and a recent Christopher Lambert as a Tarzan who imitates animals and human beings, or the masterly adaptation by Disney. Plenty to choose from for the many jungle fans of lost innocence.

1 5 10

WILLIAM WALLACE
MEL GIBSON

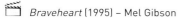 *Braveheart* (1995) – Mel Gibson

The real William Wallace was a Scottish knight and large landowner who was the leader of the resistance against the English occupation of King Edward in the 13th century. To this day, he is still a national hero in Scotland. Although not much is known about this warrior aside from what the legend tells us, Gibson managed to create a much criticised film about him. The adaptation is accused of being homophobic, xenophobic and mainly historically incorrect – from the events and names to the kilts that they wear. On the other hand, *Braveheart* won five Oscars. The truth is a minor detail compared to the heroic value of this action film. Its hero may not be realistically rendered but he is a fearless fighter, he is clever, has a sense of humour and a romantic touch. And a haircut to die for.

In the legendary battle of Stirling, the Scottish, who were far outnumbered, won against the English. In reality, the battle took place at a bridge, giving the Scots a distinct advantage. In the film, there is no bridge in sight. Instead, the Scottish victory is portrayed far more heroically. Particularly notable is Wallace's speech, encouraging the terrified Scots (who want to do a runner when seeing the overextended English approach) by saying that they are about to die, so that they better do it here. He makes them more belligerent than ever, with victory as a result. At the end of the film, William is taken captive and sentenced to death by the English. His comrades beg him to ask for mercy when he is tortured but with his last energy he screams '*Freedom*'! He dies for his cause, as a true hero should.

1 5 10

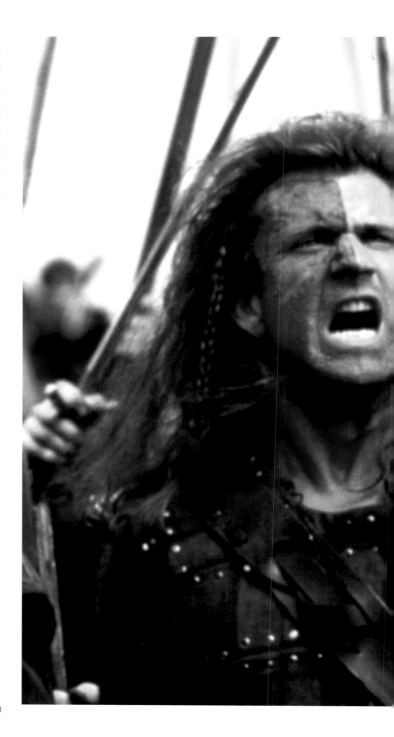

" THEY MAY TAKE AWAY OUR LIVES, BUT THEY'LL NEVER TAKE OUR FREEDOM!"

(ALMOST) REAL

The most credible heroes are the everyday ones: people
who we can identify with, of whom we can wonder that,
given the circumstances, we would do the same thing.
Many true stories have been told in film history. Stories
about the man on the street, as well as important historic
figures. Some fictitious characters nearly become real
as a result of convincing portrayals or outstanding
acting. This reality also has its share of villains. As
their character is recognisable, they become our biggest
nightmare: it could be our next door neighbour. Or worse:
ourselves. On the following pages, we stumble across
the most notorious ones. The real, and nearly real ones.
The heroes and villains we see walking on the streets.

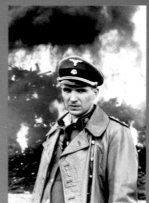

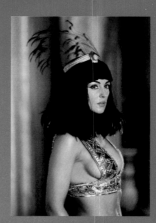

ELIZABETH TAYLOR

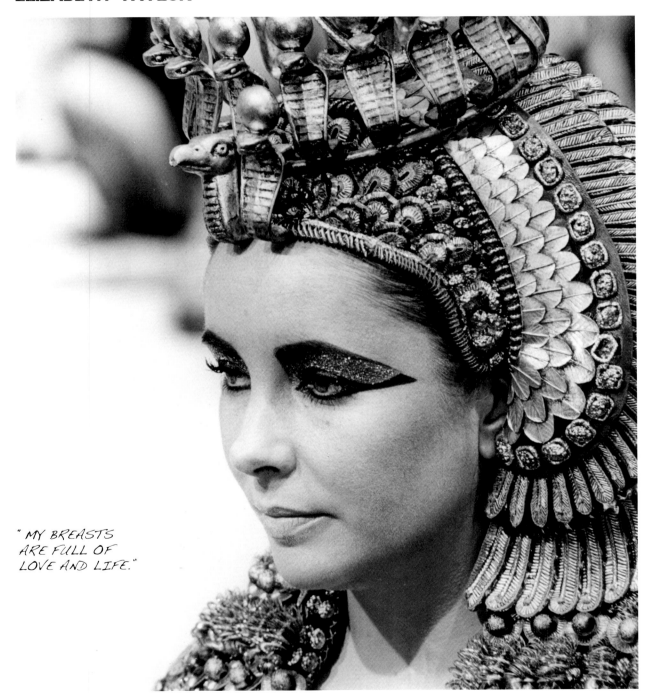

" MY BREASTS
ARE FULL OF
LOVE AND LIFE."

DANIEL PLAINVIEW
DANIEL DAY LEWIS ⓘ

There will be blood (2007) – Paul Thomas Anderson

Daniel Plainview rises from miner to oil magnate at the end of the 19th century in the state of California. He adopts the son of one of his employees who dies during an accident. Day-Lewis' rendition is hardly subtle but no less brilliant. We are left with a lasting impression of this horribly ambitious man who is prepared to give up his humanity in exchange for money and power. The struggle for power with antagonist pastor Eli Sunday (Paul Dano) is oppressive and in a scary way nearly funny. Plainview is past redemption, selfish and possessive. All his words and actions, and everyone he pretends to love, serve a higher cause: to perfect himself. It is no wonder that he ends up as an alcoholic and alone. Not short of money, but fully isolated from the world and the people he hates.

As Daniel Day-Lewis is one of the most selective actors in the film industry and a great fan of method acting, nearly all his renditions are outstanding and show great devotion. As Daniel Plainview, he exceeds himself. For example, the christening scene, in which he converts to the local church in order to obtain an oil field, is very powerful. That same power returns at the end when a fully estranged Plainview explains to pastor Eli Sunday that he has drained his land of oil by using a corny metaphor: *"I drink your milkshake"*. Upon which he kills him with a bowling pin.

1 5 10

ERIN BROCKOVICH
JULIA ROBERTS ①

"THEY'RE CALLED BOOBS, ED."

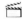 *Erin Brockovich* (2000) – Steven Soderbergh

This film is based on the true story of the real Erin Brockovich, ex-Miss Wichita and single mother of three who is given a job as an assistant in a law firm. Here, she discovers a cover-up by the Pacific Gas and Electric Company that contaminated the drinking water of a village with toxic waste, resulting in severe illnesses amongst the residents. She puts her back (and cleavage) into this case which eventually leads to a pay-out of $333 million dollars in compensation, to be divided amongst 634 plaintiffs. Julia Robert's Erin is both harsh and vulnerable, charming and captivating. Her portrayal is funny, yet realistic and transforms her in to a forceful heroine on the big screen.

Notorious for swearing, Erin Brockovich is at her best when angry. As she continuously recites crushing one-liners, the film was given an R rating. One example is when she gives the counsel for the other party tit for tat, and even better, when she makes it quite clear to the sceptical lawyers (from her own camp) that she is indispensable in this case: *"I just went out there and performed sexual favours. Six hundred and thirty-four blow jobs in five days... I'm really quite tired."* Also entertaining is that she purposefully uses her cleavage to obtain important information – although the real Erin denies doing this. Incidentally, she can be seen in a cameo role as a waitress called Julia who serves her fictional self. *Spooky.*

1 5 10

HENRY 'LOU' GEHRIG
GARY COOPER ①

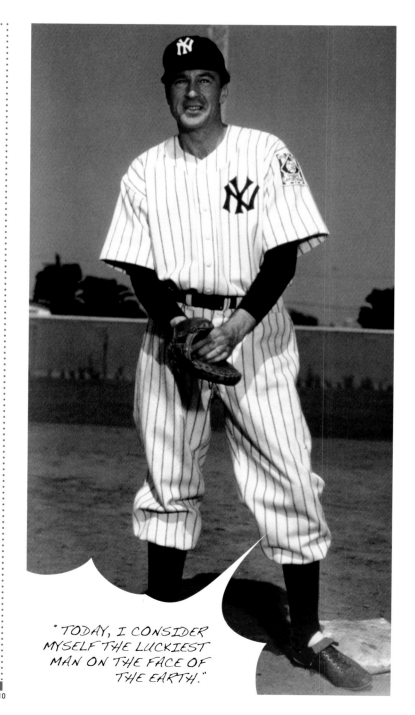

📽️ *The Pride of the Yankees* (1942) –
Sam Wood

🏷️ Frugal hardworking people are the real
American heroes. So was the left-handed
hitter of the New York Yankees, Lou Gehrig,
who died at the age of 37 of a neurological
condition. Not long after his death, his life
was portrayed in a film, starring his real
Yankee team mates such as legend Babe
Ruth. The film focuses less on him as a
talented player (who holds the record for
2,130 consecutive games) but more on the
relationships with his dominant mother, a
sport journalist friend and especially his
wonderful wife. Gary Cooper is perhaps
slightly too old to capture him in his younger
years but with his captivating smile and
timid voice, he renders the sometimes
unhandy but brave sports hero in a suitably
modest role. The film shows a string of
happy moments which may have bored the
audience, if it weren't for the fact that they
know the outcome. Every stroke of good
luck comes with a negative feeling.

🎬 The film includes Lou's famous and
emotional farewell speech in the Yankee
stadium which reveals his modest, yet
despite everything, optimistic character.
Even baseball *dummies* and people who
have never heard of Gehrig will be filled
with emotion. Just imagine the tears of the
millions of fans who relived their hero's
farewell only a year after his death. Lou's
courage and honesty also emerges in a
scene where he promises the ill boy Billy to
bat two home runs in a World Series game.
Although this is apparently not straightforward,
he, nevertheless, makes it happen.

*" TODAY, I CONSIDER
MYSELF THE LUCKIEST
MAN ON THE FACE OF
THE EARTH."*

1 5 10

JEFFERSON SMITH
JAMES STEWART ⓘ

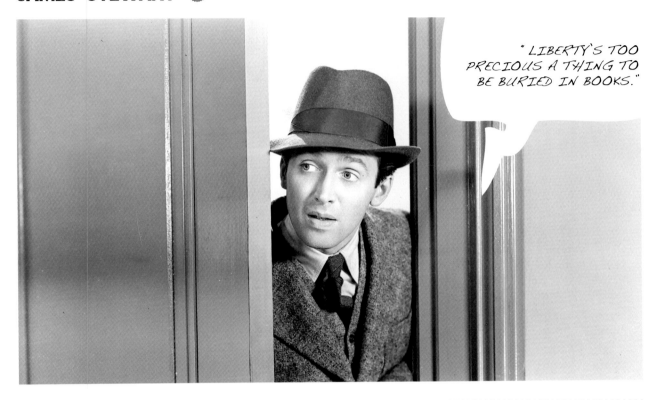

" LIBERTY'S TOO PRECIOUS A THING TO BE BURIED IN BOOKS."

Mr. Smith goes to Washington (1939) – Frank Capra

The then controversial (yet universally loved) film by Capra was accused of being anti-American, whereas its true message was an indictment of the weakening of the original values of democracy and freedom. Jefferson Smith is a naive and idealistic country scouts boy who is given the opportunity to sit in the Senate. Disillusionment hits him even harder because of his innocent optimism: he is confronted with the real world where respected 'gangsters' rule some parts of politics. The film portrays a lone, brave man and his influence on the Senate when he resorts to filibustering – a technique used to delay a bill by continuously talking until you run out of things to say, or drop down dead. Aside from it being sincere, the film is still current and above all, hilarious, including some outstanding acting from Jimmy Stewart and Jean Arthur as his cynical secretary.

At the start of his adventure in Washington, Jeff jumps on the bus and visits all the monuments, including the Lincoln Memorial which leaves him in awe. It gives you a warm feeling to see this young man walk around the grandeur of the American capital with open mouth and take it all in, something that others take for granted. He is also adorable when he reads out his bill in the Senate – visibly shaking and his voice trembling. This is in contrast with his filibuster during which he keeps a brave face despite several setbacks. He even injects a dose of humour to keep his audience and the president of the senate entertained. Though after more than 23 hours, hoarse and with a stubble, he faints. This is even too much for the corrupt politicians of whom one promptly admits to exactly how unjustly they have treated Jefferson. Luckily, Smith gets his well-deserved *happy ending*!

1 5 10

LUKE JACKSON
PAUL NEWMAN ①

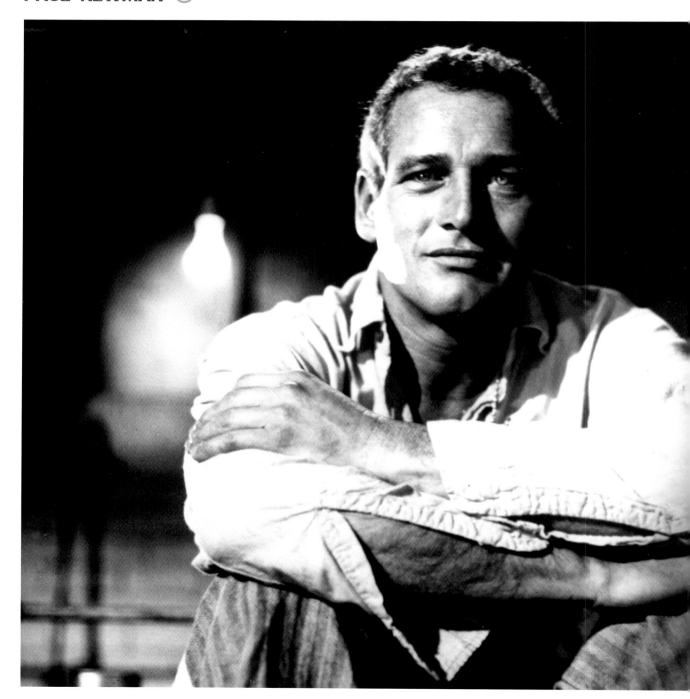

"SOMETIMES NOTHING IS A REAL COOL HAND."

Cool Hand Luke (1967) – Stuart Rosenberg

War hero Lucas Jackson is sentenced to two years in a prison camp in Georgia for vandalising parking meters one drunken night. His independent spirit and roguish sense of humour make him unpopular with the guards (or '*bosses*'), but adored by the prisoners. His nickname is the result of a game of poker which he won on a bluff. With the enigmatic charm that characterises Luke, Paul Newman has created one of the most convincing autonomous spirits in cinema history. Even when a depression is lurking, he continues to charm friends and irritate foes.

All Luke's actions take on mythical proportions as he is idolised by his inmates: the boxing match where he suffers a beating but wins endless respect, the bet that he can eat fifty eggs in one hour – which he wins, when he convinces the other prisoners to finish the road as quickly as possible to show up the guards, his many escapes and naturally, his final words: "*What we've got here is a failure to communicate*" in which he imitates the sadistic camp leader.

1 5 10

MARQUISE DE MERTEUIL

ANNETTE BENING

Les Liaisons Dangereuses (1959) – Roger Vadim
Dangerous Liaisons (1988) - Stephen Frears
Valmont (1989) - Milos Forman
Cruel Intentions (1999) - Roger Kumble

Additional actresses: Jeanne Moreau and Sarah Michelle Gellar

La Marquise de Merteuil is a character from the famous novel *les Liaisons Dangereuses* by Choderlos de Laclos from 1782. She is brilliantly portrayed by Glenn Close and Annette Bening and must be included in this book. Both mean and witty, she has an incredible talent to scrub round or bend the rules and morale of her time. Her attempts to (sexually) corrupt innocent people do not only harm the reputation of others but unwittingly also her own, which makes her an intriguing character to who we would love to see fail. Remarkable are Juliette de Merteuil by Jeanne Moreau and Kathryn Merteuil in *Cruel Intentions*: both are modern day renditions of 18th century characters: bored socialites from Paris in the 1960s, and New York. In both cases, Merteuil is wonderfully wicked.

Marquise de Merteuil, in all her personifications, knows exactly how to manipulate others. This is most entertaining when she wins Madame de Volanges and her daughter Cécile over but plays different cards on them. The several film versions are motivated by the sexual tension between her and Valmont, particularly when this becomes a sheer habit instead of a heartfelt emotion. From then on, she is stuck in an unstoppable downwards spiral and will eventually pay for all her tricks and schemes with that what she has fought for most: her name and reputation. This is cleverly portrayed, particularly in Frears' version, when Glenn Close fiercely removes her make-up. With her tears, also her mask falls.

" I BECAME A VIRTUOSO OF DECEIT."

1 5 10

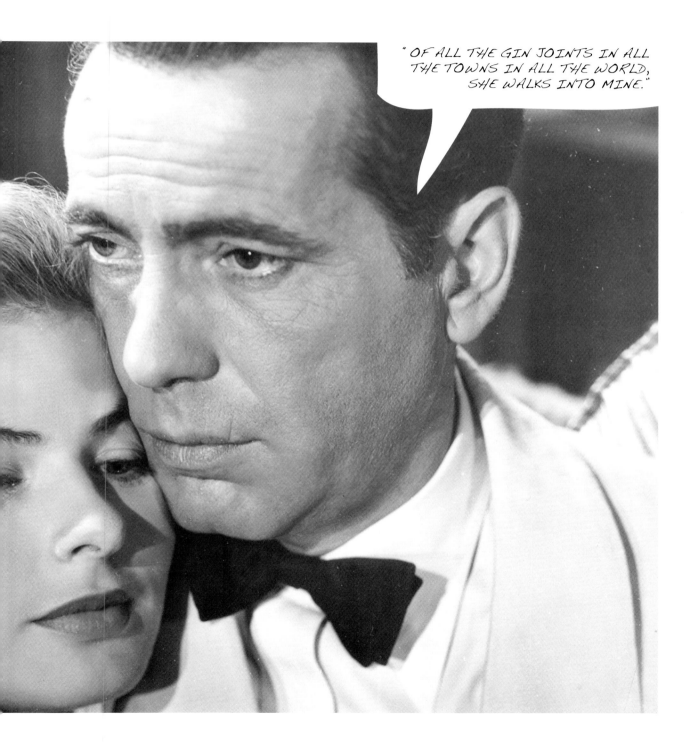

T.E. LAWRENCE
PETER O'TOOLE ①

" NOTHING IS WRITTEN."

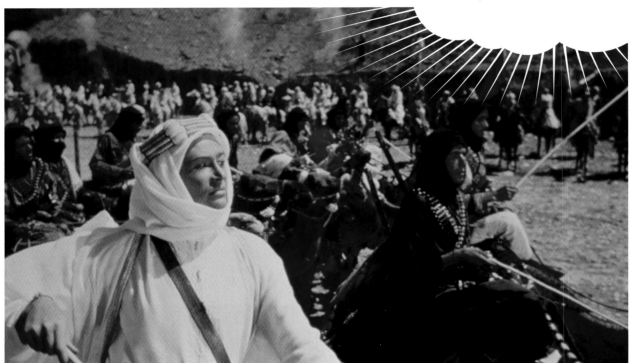

🎬 *Lawrence of Arabia* (1962) – David Lean

🏷 This four hour epic, one of the most influential films in history, is more than just a biography of a historical character. Blue eyed and eccentric T.E. Lawrence is a misfit British Army lieutenant stationed in Cairo during WWII. Notorious for his brutality and knowledge of the Bedouins, he is sent into the desert to assess Prince Feidal's (Alec Guinness) plans. The sandpit becomes the stage of the adventures of this flamboyant and slightly odd hero. He unites a theatrical charisma with lunacy. We see his personal struggle with violence (which he enjoys) and his attraction to the Arabic dynamics, as opposed to the British stiffness. Although it is a known fact that Lawrence was homosexual, the film does not explicitly reveal this, nor hide it for that matter... Look at the appearance and acting of O'Toole for example, and his relationships with the different men in the film (with not one woman in sight!).

What we remember from this endlessly long classic: After a long journey through the treacherous Nefud desert, Lawrence returns to save one of the men, Gasim, who was left behind. Later on, through circumstances, he must execute him which mainly troubles him because he enjoys it. Also entertaining: Lawrence's dance after he is given traditional Arabic clothing by Sheriff Ali (Omar Sharif) and the controversial torture scene by the Bey officer, which only turns Lawrence into a more sadistic enemy. Though what is truly memorable, are the long, silent and bare crossings through the desert. A dot on the horizon slowly changes into a man. It is breathtaking and provides a better perception of Lawrence than any other scene.

1 5 10

TERRY MALLOY
MARLON BRANDO ①

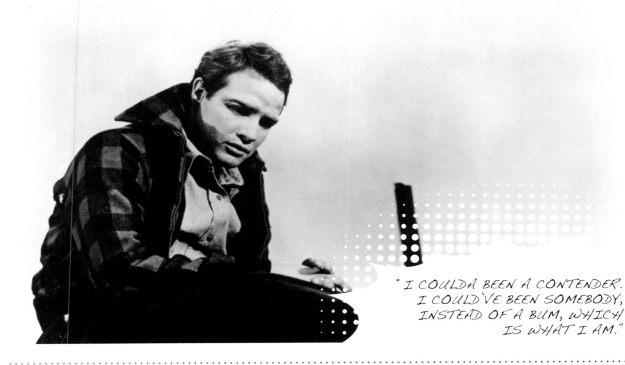

*" I COULDA BEEN A CONTENDER.
I COULD'VE BEEN SOMEBODY,
INSTEAD OF A BUM, WHICH
IS WHAT I AM."*

On the Waterfront (1954) – Elia Kazan

This story of Mob informants was filmed during the communist prosecution in America (during which director Kazan had revealed names), in and around the docks of Hoboken where real dockworkers appeared as extras. Terry, in the famous red and black checked jacket, is a former boxer who is conscience-stricken after he was made an accomplice to murder of a possible informant. He is even more confused by the love he feels for the mole's sister Edie (Eva Marie Saint). Gangster Johnny Friendly gloats about his iron fisted control over the docks and unions and all witnesses play D&D (*'deaf and dumb'*). Marlon Brando perfectly balances the tension between Terry's macho appearance and gentle character. His sexual arrogance and cockiness alternate with tormented sensibility. There is something moving about him.

This film, rated by many as the best one in history, pictures one of the most famous and particularly tear-jerking scenes ever: Terry is picked up by his brother Charley (Friendly's right hand man) in a taxi. In an attempt to convince him not to talk, Charley pulls his gun which leaves Terry looking disappointed. He realises that he has been used and that his chances of becoming a professional boxer were nipped in the bud by Charley. He speaks legendary and poetic words. Less grand but equally memorable is Brando's genius acting which is outstanding in the scene where he improvises when Edie's glove accidentally falls. And *last but not least*, there is the ending when Terry triumphs and deserves his place amongst the biggest heroes.

1 5 10

THELMA & LOUISE
GEENA DAVIS ① & SUSAN SARANDON ①

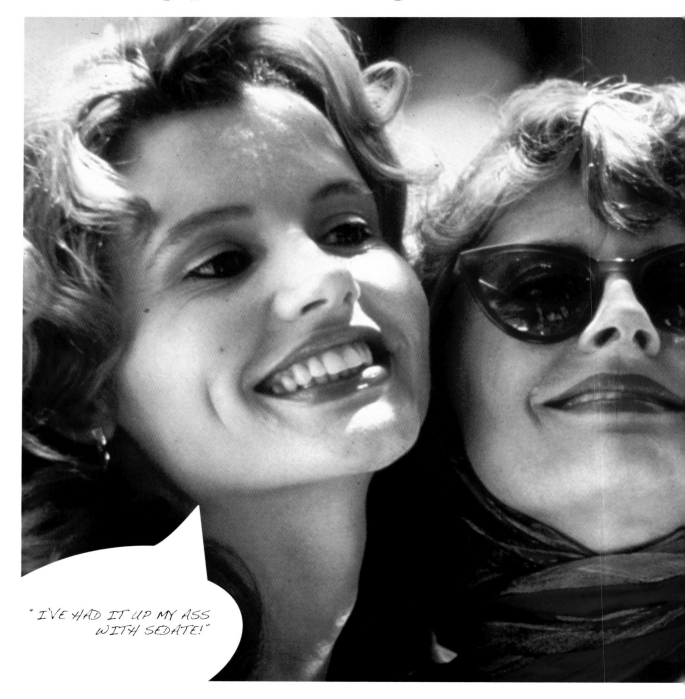

"I'VE HAD IT UP MY ASS WITH SEDATE!"

 Thelma & Louise (1991) – Ridley Scott

A waitress with an unhappy past (Louise) and a housewife with an ego tripping husband (Thelma) go out fishing. They have hardly taken off when Louise kills Thelma's assaulter. Reluctantly, they jump back into their 1966 Thunderbird and embark on a fatalistic journey which also happens to be wickedly funny and touching. The American road movie classic has been given a face-lift: the buddies are two women. The transformation they go through remains the same: Louise becomes more subdued and insecure, whilst Thelma emerges to be a frantic shop-lifter. Their appearance takes on a 180 degree turn. The incompetent and sexist men in their lives become the motive for their crimes – yet only one can be trusted: Harvey Keitel as a police detective with people skills. The unprecedented freedom gives them such a high that they refuse to give it up.

The end of *Thelma & Louise* is world-famous: a freeze frame of the T-Bird in mid-air above the Grand Canyon. Shame that the end credits immediately appear. If they had shown the floating car a little longer, it would have balanced out the action in the rest of film – which, obviously, contains a wide range of other entertaining moments. They encounter a truck driver who repeatedly makes obscene sexual gestures to them on the road. They pull him over, under the presumption of giving him a good time, but instead, they lecture him about manners and fire at his fuel tank, causing it to explode. Also amusing: a sexually frustrated Thelma meets the young but sexy Brad Pitt, who is more than willing to help her out. In cowboy outfit!

1 5 10

OUT OF CATEGORY

The following characters cannot be classed in any other group and are literally 'out of category'. They appear in genre films that do not belong in the previous chapters, or they are entities in their own right. From extremely shy to unrelentless and vindictive. From femme fatale and schizophrenic fantasy to heroes from blaxploitations or film noirs: all characters passing in review have been chosen for the most diverse reasons. They are the hero of the story, or the villain, or both... You will meet a child with his alien friend, a nanny with flying umbrella and a bride with samurai sword who is after revenge. You name it and there is a film about it!

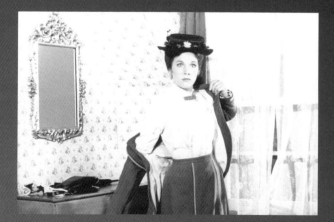

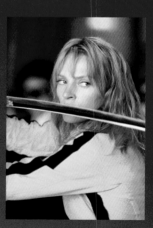

OUT OF CATEGORY

AMELIE POULAIN
AUDREY TAUTOU

"VOUS AU MOINS NE RISQUEZ PAS D'ÊTRE UN LÉGUME PUISQUE MÊME LES ARTICHAUTS ONT DU CŒUR !"

Le Fabuleux Destin d'Amélie Poulain (2001) – Jean-Pierre Jeunet

Although she received many negative reviews, Amélie Poulain is one of the most positive film heroines ever. She goes through life (playfully, yet pained) like a pierrot or star from a silent film: frisky and innocent, with the biggest eyes for the audience to loose themselves in. Similar to Audrey Hepburn, not really sexy but attractive for young and old, men and women. This modern day fairy tale starts on the day of Lady Diana's sudden death. She decides to secretly make small changes to the diverse lives of the other characters. Partly out of kindness, but also to compensate for the fact that she is too insecure to alter her own life. When she falls in love with another outsider, she has to come out of her shell.

Intriguing is the perfectly orchestrated courtship display or search for the man of her dreams through the idealised streets of Paris. Or her father's gnome who travels the world. Or when she takes revenge on greengrocer Mr Collignon for his unfair treatment of Lucien, his assistant, by making him believe that he is going mad. Most memorable is the accurate depiction of a well-known feeling: when your heart sinks into your boots or unhappiness makes you want to curl up in a corner and disappear. Amélie crashes down like a bucket of water. And all that is left is a puddle on the floor.

1 5 10

AURIC GOLDFINGER
GERT FROBE

⚠

🎬 *Goldfinger* (1964) - Guy Hamilton

🏷 *Goldfinger* offers a gripping Bond experience, from the first notes of Shirley Bassey's theme song. The villain on duty is Auric Goldfinger, perhaps the most sinister of all Bond baddies – even more than Blofeld, Dr. No or le Chiffre. He is a gold smuggler, obsessed by precious metals and played by Gert Fröbe, voiced by Michael Collins. From the moment when he covers a girl in gold paint which kills her by epidermal suffocation, we realise that Auric is cruel and merciless. Not only is he intelligent and resourceful, he is also helped by an old granny armed with a machine gun, the nearly frigid but sexy pilot Pussy Galore and the mute Korean Oddjob who cannot be defeated in an honest fight – due to his supernatural powers and flying bowler hat made from steel. Shame that the Venetian blond villain did not kill Bond when he had the chance as he gets sucked through a plane window at the end of the film.

📺 Known by all is the scene in which James Bond narrowly escapes having his private parts zapped by an industrial laser. Also typical of Goldfinger, as nearly every villain before and after him, is that he likes to show off his skills. A hilarious example: Auric presents Operation *Grand Slam* (irradiate the gold supply at Fort Knox which will increase the value of his own gold) to the Mafia bosses with a sophisticated presentation including revolving floors and walls, and beautiful scale-models. To then gas all the gangsters. Huh? Luckily, James was hiding and heard all details...

"NO MR. BOND, I EXPECT YOU TO DIE."

1 5 10

BEATRIX KIDDO AKA THE BRIDE
UMA THURMAN

" IT'S MERCY, COMPASSION AND FORGIVENESS I LACK. NOT RATIONALITY."

Kill Bill vol. 1 (2003), *Kill Bill vol. 2* (2004) – Quentin Tarantino

Beatrix Kiddo is a former assassin who is shot dead at her wedding rehearsal, also killing her fiancé, family and unborn child (so she believes). When she awakens from a coma by a buzzing mosquito, she seeks revenge on all members of her old 'team' (*the Deadly Viper Assassination Squad*), with her boss (and previous *lover*) Bill as the cherry on the cake. All this takes place in an artificial world, with homages to several films and genres, mainly martial arts (a number of characters are even played by legends in this genre). The main characters (nearly all women) are all defined by their weapon. The signature weapon of 'Black Mamba', her code name, is a razor-sharp Hattori Hanzo sword. In this action thriller, partly inspired by *Lady Snowblood* from 1973, Uma Thurman (Tarantino's favourite actress) becomes an endearing, yet drop dead sexy and ruthless heroine seeking revenge, dressed in a yellow tracksuit.

In volume 1, Beatrix – whose name is unknown at this point – single-handedly kills the Crazy 88 of O-Ren Ishii (Lucy Liu). Though later on it is revealed that there were not really 88 henchmen, the fight remains an impressive *tour de force*. Volume 2 includes one of the most claustrophobic scenes ever: the bride is buried alive by Budd (Michael Madsen), with only a torch to keep her company. Pure determination allows her to break out of the coffin and dig her way up to the surface. Impressive, hands up. As ever with Tarantino, we are treated to his foot fetishism which in this film presents itself during a crucial and long scene in which Uma (shoe size 9), who has just woken up from a coma, tries to make her toes wriggle.

1 5 10

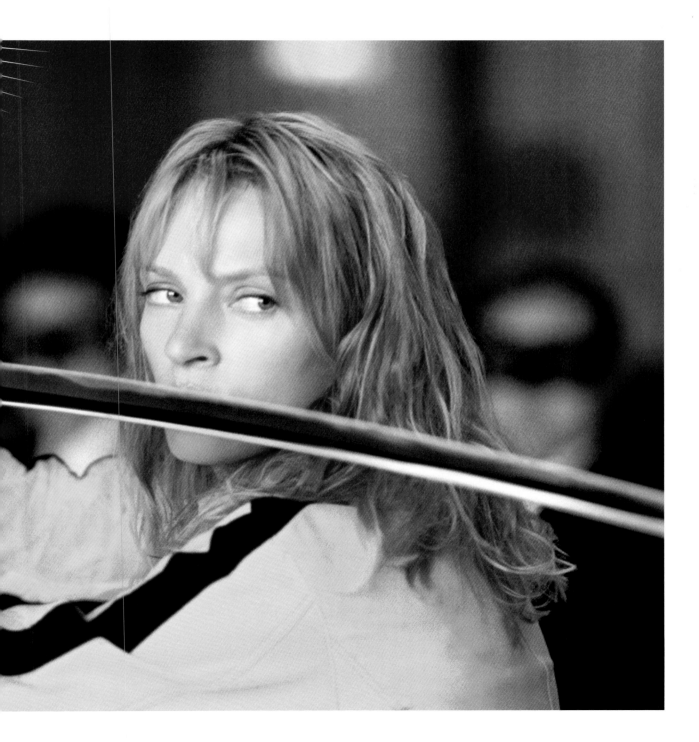

DJANGO
FRANCO NERO

⚠

🎬 *Django* (1966) - Sergio Corbucci, *Django 2: Il grande ritorno* (1987) - Nello Rossati

🏷 *Django* was the father of the spaghetti Western, and one of the most violent films of its time – the ear-severing scene, that inspired Tarantino, had a bit of an impact. Aside from the more than thirty unofficial sequels, many more references are made to this cult film. Franco Nero (barely 24 years old but seemingly worn-out) is Django, a blue eyed stranger with a coffin, motivated by revenge for the murder of his wife. All this takes place in a muddy ghost town in the Wild West, home to a Mexican gang of bandits and a murderous racist clan, armed with red hoods and flaming crosses. His worn-out clothes and unshaven (though surprisingly handsome) look makes Django a real antihero, solely motivated by revenge and money. And although he rescues the young prostitute Maria from certain death and gives her smouldering looks from underneath his black hat, the excessively violent film remains rather prudish.

🎞 The opening scene is both legendary and iconic. The evocative image of a man dragging a coffin through the mud is at odds with the opening of the traditional American Western where the hero usually comes galloping from a distance like a king on his horse. The first time that he opens the coffin and a ludicrously big machine gun is revealed, is also unforgettable. In particular, the pleasure in Django's eyes when he uses the gun to shoot a bunch of clan members is priceless. The end of the film is also well known. Even now his hands have been crushed, Django still manages to kill his biggest enemy at the symbolic location of the cemetery, near the grave of his wife.

"YOU CLEAN UP THE MESS, BUT DON'T TOUCH MY COFFIN."

1 5 10

ELLIOTT
HENRY THOMAS

E.T.: The Extra-Terrestrial (1982) - Steven Spielberg

The family of ten year old Elliott (with older brother Michael and younger sister Gertie) has just been abandoned by their father and they often feel lonely and unhappy. Particularly Elliott is in need of a good friend which he finds in E.T., an alien that has been accidentally left behind on earth by his friends. Both feel let down. This fairy tale about an impossible friendship in an adult and cruel world is predominantly told through the eyes of the child or the alien. It is therefore extremely frustrating to see that no one believes Elliott (who now has a mental and physical connection with the extra-terrestrial) when he says that E.T. is about to die. Although he initially would like E.T. to live with him, he later tries his hardest to help him return home.

Many scenes in this film have become classics but one of the most beautiful moments has to be the following: Elliott and Michael go out on Halloween with E.T. (disguised as Gertie, dressed as a ghost) so he is able to go home. This funny sequence (when E.T. runs after someone dressed up as Yoda, shouting '*home*') is immediately followed by one of the most magical film moments in history, giving every child goose bumps (and BMX an increased profit in the eighties). E.T. invites Elliott to join him on a flying cycling trip above the woods, and to the well-known score of John Williams, they zoom past the moon. Also memorable is the audition of the little Henry Thomas (included in the DVD Extras) who is able to genuinely sob his heart out on demand. At the end of his audition, you can hear Steven Spielberg say: '*Okay kid, you've got the job.*' Rightly so.

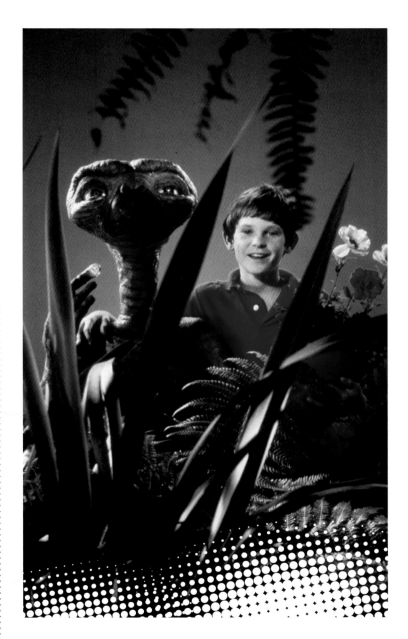

" I`LL BELIEVE IN YOU ALL MY LIFE, EVERY DAY."

1 5 10

FOXY BROWN
PAM GRIER

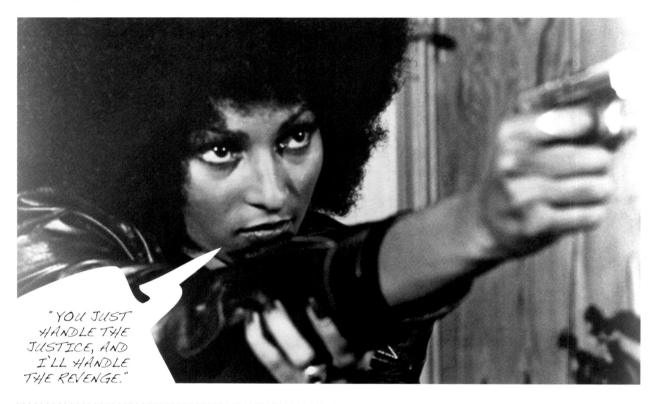

"YOU JUST
HANDLE THE
JUSTICE, AND
I'LL HANDLE
THE REVENGE."

🎬 *Foxy Brown* (1974) - Jack Hill

🏷 Pam Grier is the most popular of the blaxploitation heroines from the seventies. These are exploitation films (low-budget films exploiting sex, drugs and violence) with primarily black actors. Although the storyline is hardly relevant, let's quickly summarise: Foxy seeks revenge for the murder of her boyfriend, an undercover police agent in the drugs world, who was betrayed by her brother, a dealer. In order to infiltrate, she decides to pose as a prostitute, to show off her plunging neckline, to change her hair and outfits numerous times and to teach over-familiar men a valuable lesson. Her brother calls her 'a whole lot of woman' and this is no understatement: Foxy Brown succeeds in her actions thanks to her appearance and sex appeal. She is seductive, yet vigorous whilst she mercilessly punishes the bad guys. In spite of the narrative blunders, unclear message and politically incorrect language, *Foxy* is simply fun to watch!

When it is payback time, Foxy will not simply murder the evil villains. She wants to see them suffer. Mr Elias is the object of affection of Miss Katherine, drug baroness and madame. They have a kinky relationship, and Foxy knows exactly what to do. We will never forget Mr Elias' castration and the presentation of his severed genitals to Katherine – who no longer sees the purpose in living now her boyfriend can no longer perform. It's all about priorities. From the numerous other (sometimes slow going) action scenes, we mainly remember the fight in the lesbian bar with chairs flying around and the thought that political incorrectness can also be extremely funny.

1 5 10

HANS LANDA
CHRISTOPH WALTZ ①

"THAT'S A BINGO!"

🎬 *Inglorious Basterds* (2009) – Quentin Tarantino

🏷 Colonel Hans Landa is a German SS officer, who is nicknamed The *Jew Hunter*. The character and its rendition is unparalleled in this eccentric film about cinema and the end of WWII. It is, without doubt, one of the most charming, yet evil villains ever. He is ruthless but polite, diabolically intelligent and sly. He says the most wicked things with a smile, and this in four languages. Landa is so eloquent that he is able to imaginary hang someone using words. He is not driven by ideology and therefore does not believe in Nazism either. He will gladly switch over to the party that will be most advantageous to him, or even better, that which takes his fancy at that moment. The role is perhaps a little cliché but Christoph Waltz makes him ever so slightly brilliant.

⌐ The highlight of *Inglorious Basterds* is set with the opening scene when Landa interrogates a French farmer and pressures him in the most charming way possible to find out if he is hiding a Jewish family underneath his floor. When the colonel lights his enormous pipe, the immediate threat of the situation vanishes and he is suddenly stripped of all his importance, perhaps doubting his masculinity? A comparable moment occurs when he is eating apple strudel with Shosanna Dreyfus and advises her to wait for the fresh cream. She knows that he has killed her family, and you expect him to act accordingly, which he doesn't. And it is wretched, waiting for that cream...

1 5 10

MARY POPPINS
JULIE ANDREWS ⓘ

🎬 *Mary Poppins* (1964) – Robert Stevenson

🏷 Mary Poppins is a character from the book series by P.L. Travers, first published in 1934. She is more friendly and kind in the film version than in the books but the charming and angel voiced nanny is also mysterious and strict. Mary Poppins parachutes down (we have no idea where from) with her umbrella, landing in Edwardian London where she is about to resolve the family Banks' problems. To get attention from their father, the children scare away every nanny they have had. Mary Poppins – Julie Andrews' debut on the big screen, with her typical appearance (The shoes! The hat!), modelled after the illustrations by Mary Sheppard – encourages the father to spend more time with his children, applying some unconventional methods. With the help from her bottomless carpetbag and other magic, she is *supercalifragilisticexpialidocious* in this musical fairy tale.

🎞 *Mary Poppins* is part of everyone's youth and many scenes are widely known, which does not make them any less good. How can we forget Michael and Jane's joy when they find out that you can clear up your room with a single snap of your fingers? Or the wacky tea party on the ceiling? Perhaps the trip to the lively countryside, with the fox hunt and horse racing? Or maybe the dance of the chimney sweepers on the London roofs, when Mary astonishes everyone by endlessly pirouetting? Add a sentimental but happy ending when Mary Poppins can leave London with an easy mind, comfortably hanging from her umbrella and heels clicking, and then we remember why this film is such a classic.

" PRACTICALLY PERFECT IN EVERY WAY."

1 5 10

PHILIP MARLOWE
HUMPHREY BOGART

Murder, My Sweet (1944) – Edward Dmytryk
The Big Sleep (1946) – Howard Hawks
Lady in the Lake (1947) – Robert Montgomery
Marlowe (1969) – Paul Bogart
The Long Goodbye (1973) – Robert Altman
Farewell My Lovely (1975) – Dick Richards
The Big Sleep (1978) – Michael Winner

Addition actors: Dick Powell, Robert Montgomery, James Garner, Elliott Gould and Robert Mitchum

Raymond Chandler's private detective, who has a soft spot for female clients and whiskey and who explores the underworld of LA, has often been portrayed on the big screen – by Dick Powell, Elliott Gould (in a post-modern version) and Robert Mitchum amongst others. But whoever says Marlowe, inevitably thinks of Humphrey Bogart. The books are confusing and *The Big Sleep* from 1946 has no intention of trying to simplify things, on the contrary. What is important is how often Bogart and Bacall fall into each other's arms. An additional version, including more scenes, was released to recreate the sparks of their first encounter in *To Have and Have Not*. Besides, the film is hardly worth watching for its storyline. Bogart as Marlowe, the drinking, smoking and mumbling *private eye* can hardly be called God's gift to women and to make it worse, he has elocution problems. Though strangely enough, there is something about him – which is partly due to the wonderful and ambiguous dialogues.

The best Marlowe moments in *The Big Sleep* are those when Humphrey makes a (usually successful) attempt to flirt. This is the case in the scenes with Lauren Bacall, most strikingly when they discuss 'racehorses'. Much depends on who rides the horse, and you can use your imagination to fill in the rest... Even more entertaining is when Bogart questions the saleswoman in a book shop (Dorothy Malone). Whilst she allows herself to be courted, it starts to rain outside and Bogart mentions – when he realises that he is carrying a bottle of whiskey – that he would rather get wet inside than outside. The girl promptly shuts the curtains and closes the shop for the rest of the afternoon...

" I COLLECT BLONDES AND BOTTLES TOO."

1 5 10

PHYLLIS DIETRICHSON
BARBARA STANWYCK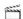

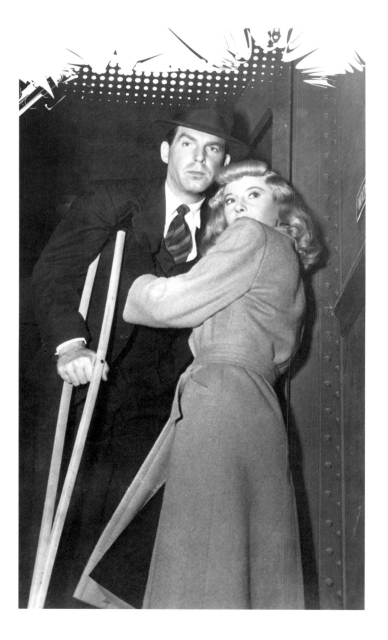

Double Indemnity (1944) – Billy Wilder

The title of the novella by James M. Cain and the characteristic film noir of the same name refers to a clause in an insurance policy that doubles the pay-out in the event of accidental death. Troubled insurance salesman, Walter Neff (Fred MacCurray) meets Phyllis Dietrichson, a lethargic blonde with a cheap blond wig and, probably, equally cheap perfume. Walter quickly falls under the sexual spell of Phyllis, although she is cold and predictable. She invents an ingenious plan to kill Mr Dietrichson and mislead the insurance company. Keyes (Edward G. Robinson), mentor and friend of Walter, is a claims adjuster and soon unravels the truth. Lola, the daughter of the murdered husband, also suspects Phyllis to have killed both her father and mother. It is the first time that Hollywood looks at the motives and means of a killer. `

The first time both Walter and the audience get to see Phyllis is when she is standing at the top of the stairs draped in only a towel. One look at her sexy anklet and the insurance salesman is sold. When Walter kills her husband, we see a close-up of Barbara Stanwyck's face against a black background. The expression in her eyes leaves a lasting impression, which her stepdaughter Lola will later describe when she is talking about the death of her mother. The first time that Phyllis truly shows her teeth is when she secretly meets up with Walter in a supermarket. He wants out but his mistress forbids him by threatening him. Their passion has now vanished – in any case, she was always simply going to use him.

" I'M ROTTEN TO THE HEART."

1 5 10

RHETT BUTLER
CLARK GABLE ①

" WITH ENOUGH COURAGE, YOU CAN DO WITHOUT A REPUTATION."

🎬 *Gone With the Wind* (1939) - Victor Flemming

🏷 Rhett Butler, a visitor from Charleston, a black sheep, is the hero in *Gone with the Wind*, the classic of all classics that takes place during the golden age of the Old South and the American Civil War. Butler, with his smug laugh and Clark Gable's moustache, wants Scarlet O'Hara (Vivien Leigh) from the second he lays eyes on her. Scarlet is scared of the lust that she feels for him, a man who is as despicable as she is. With his charisma and rough, straightforward approach, he manages to seduce her – and the audience. Rhett heroically kisses Scarlet and manages to leave her as only a hero could (twice in the film at crucial moments). His role is dramatic but what we remember from this overwhelming production are the smouldering looks and unforgettable quotations.

He tells her quite quickly that she urgently must be kissed but it isn't until another husband later that it finally happens. Rhett gives her spaghetti legs when he kisses her wildly (one of the most famous film kisses in history) and wishes that she would faint as she has never been kissed by a man like this before. Aside from this superb scene, we will also never forget how he walks into the mist, out of Scarlet's life and back into his old habits, with the outrageous, yet well-known words: *"Frankly my dear, I don't give a damn."*

1 5 10

TYLER DURDEN
BRAD PITT

📽 *Fight Club* (1999) – David Fincher

🏷 Originally, Tyler Durden is a character from a novel by Chuck Palahniuk. He is incredibly charismatic and everything we and the unnamed narrator dare to be. He inserts male body parts in family photos, wees in the soup, sleeps with your girlfriend, quite happily beats you up and has the looks you have always wanted – like an extremely cool Brad Pitt, that is. Tyler is an anarchist who despises consumer culture. Together with the narrator, he is the co-founder of *Fight Club*, a group of frustrated men who can let off steam by 'kindly' knocking each other out. Later, he sets up *Project Mayhem*, with which he would like to create an ideal world, which to him means: a post-apocalyptic and therefore destructed world with which we can start afresh. As the film proceeds, the narrator finds out why he struggles to stop Tyler continuing with his insane plans.

🎬 From the beginning, *Fight Club*, which you really must see twice, shows Tyler (literally) between the lines. He appears on screen in short flashes but is only recognisable if you pause at the exact second. Later on, Tyler talks about one of his jobs in a cinema where he had to stick together reels of film, and couldn't resist inserting obscene images – which, not incidentally, happens at the end of the film. We also remember the first night of the *Fight Club* and the instant legendary speech about its rules, as well as the final image, when all is back to normal and Edward Norton tells Helena Bonham Carter that everything will be ok. With *Where is my Mind?* by the Pixies in the background, all buildings outside blow up. Strangely enough, a hopeful scene.

1 5 10

" IT'S ONLY AFTER WE'VE LOST EVERYTHING THAT WE'RE FREE TO DO ANYTHING."

INDEX

QUOTES

p. 154 *"They may take away our lives, but they'll never take our freedom!"*
Mel Gibson, Braveheart (1995)

p. 158 *"We have the fucking power to kill, that's why they fear us."*
Ralph Fiennes, Schindler's List (1993)

p. 159 *"You never really understand a person until you consider things from his point of view, until you climb inside of his skin and walk around in it."*
Gregory Peck, To Kill a Mocking Bird (1962)

p. 160 *"My breasts are full of love and life."*
Elizabeth Taylor, Cleopatra (1963)

p. 162 *"I've abandoned my child! I've abandoned my child! I've abandoned my boy!"*
Daniel Day-Lewis, There will be blood (2007)

p. 163 *"They're called boobs, Ed."*
Julia Roberts, Erin Brockovich (2000)

p. 164 *"Today, I consider myself the luckiest man on the face of the earth."*
Gary Cooper, The Pride of the Yankees (1942)

p. 165 *"Liberty's too precious a thing to be buried in books."*
James Stewart, Mr. Smith goes to Washington (1939)

p. 166 *"Sometimes nothing is a real cool hand."*
Paul Newman, Cool Hand Luke (1967)

p. 168 *"I became a virtuoso of deceit."*
Glenn Close, Dangerous Liaisons (1988)

p. 170 *"If Mr. McMurphy doesn't want to take his medication orally, I'm sure we can arrange that he can have it some other way."*
Louise Fletcher, One flew over the cuckoo's nest (1975)

p. 171 *"These are my workers. They should be on my train. They're essential."*
Liam Neeson, Schindler's List (1993)

p. 172 *"Of all the gin joints in all the towns in all the world, she walks into mine."*
Humphrey Bogart, Casablanca (1942)

p. 174 *"Nothing is written."*
Peter O'Toole, Lawrence of Arabia (1962)

p. 175 *"I coulda been a contender. I could've been somebody, instead of a bum, which is what I am."*
Marlon Brando, On the Waterfront (1954)

p. 176 *"I've had it up my ass with sedate!"*
Geena Davis, Thelma & Louise (1991)

p. 180 *"You don't risk being called a vegetable, since even an artichoke has a heart!"*
Audrey Tautou, Le Fabuleux Destin d'Amélie Poulain (2001)

p. 181 *"No Mr. Bond, I expect you to die."*
Gert Fröbe, Goldfinger (1964)

p. 182 *"It's mercy, compassion and forgiveness I lack. Not rationality."*
Uma Thurman, Kill Bill vol. 1 (2003)

CREDITS

Photography:
All images British Film Institute,
except pages 18, 36, 42, 52 (Image Gerorge Clooney), 71, 88, 98, 115, 130, 131, 153, 168, 170, 164 and 171 (Corbis)
and pages 61 en 63 (Cinematek)

Translations:
English translation: Lotte Scott